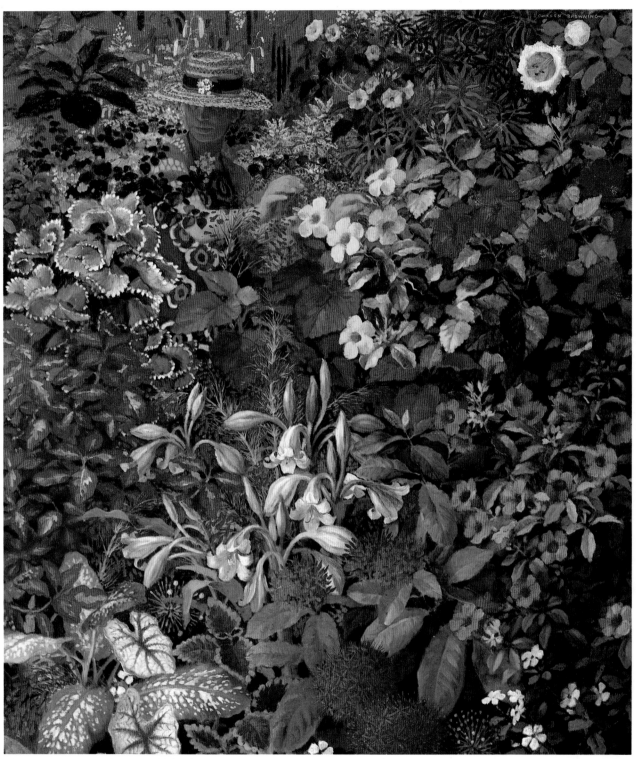

LILY, 1980, 42" × 48" (106.6 × 121.9 cm).

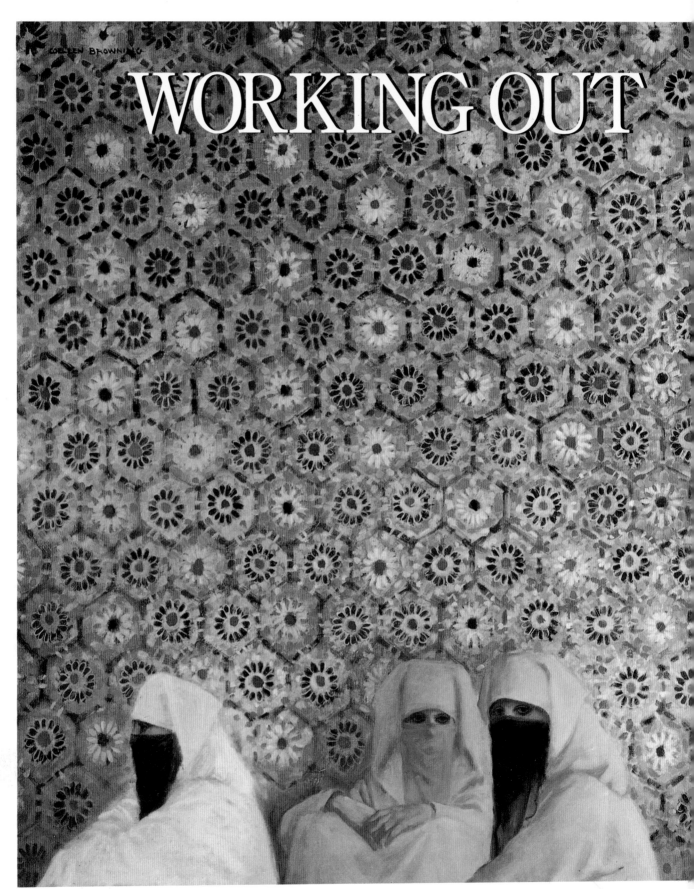

WORKING OUT

AT FEZ, 1968, 47½" × 28½" (120.5 × 72.3 cm).

A PAINTING

Colleen Browning

WATSON-GUPTILL PUBLICATIONS/NEW YORK

Copyright © 1988 by Watson-Guptill Publications

First published 1988 in the United States and Canada by Watson-Guptill
Publications, a division of Billboard Publications, Inc., 1515 Broadway,
New York, N.Y. 10036.

Library of Congress Cataloging-in-Publication Data

Browning, Colleen.
 Working out a painting.

 Includes index.
 1. Human figure in art. 2. Painting—Technique.
I. Title.
ND1290.B76 1988 751.45 88-17280
ISBN 0-8230-2994-8

Distributed in the United Kingdom by Phaidon Press Ltd., Littlegate
House, St. Ebbe's St., Oxford

Manufactured in Japan

First Printing, 1988

1 2 3 4 5 6 7 8 9 / 93 92 91 90 89 88

FOR GEOFFREY

I would like to thank Bonnie Silverstein, whose enthusiasm and support made the writing of this book a pleasure; and Candace Raney, organizer-in-chief, for all her invaluable help; also Geoffrey Wagner, my husband, uncomplaining typist, and altogether my favorite person.

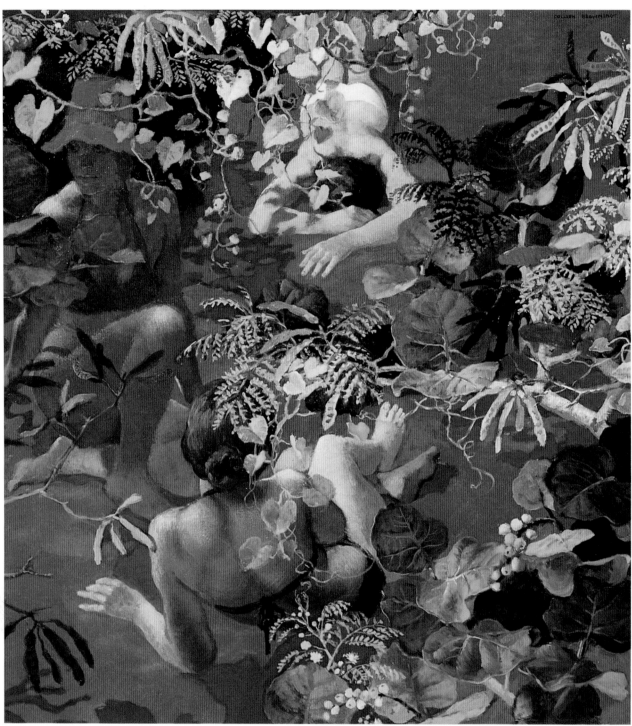

THREE, 1983, 38″ × 38″ (106.6 × 106.6 cm).

CONTENTS

INTRODUCTION 9

PART 1
DRAWING FOR PAINTING 10
PRELIMINARIES 12
THE FACE AND HEAD 14
THE FIGURE 26
COSTUME 32
DRAWING ON TINTED PAPER 36

PART 2
THE ESSENTIALS OF PAINTING 42
MATERIALS 44
BASIC WAYS TO APPLY PAINT 48
VALUE 52
COLOR 58
COMPOSITION 66

PART 3
WORKING OUT AN IDEA 74
PRELIMINARY DECISIONS 76
MAKING A PAINTING 78
CHANGING A PAINTING 86

PART 4
DEVELOPING A PAINTING 94
FIESTA 96
SUMMER 108

PART 5
PAINTING POSSIBILITIES:
PROBLEMS AND SOLUTIONS 120
THE MULTIVIEW PORTRAIT 122
URBAN PATTERNS 124
EXOTIC PLACES 128
MYSTIC VISIONS 130
TROPICAL IMAGES 136
SEASIDE SCENES 142

INDEX 144

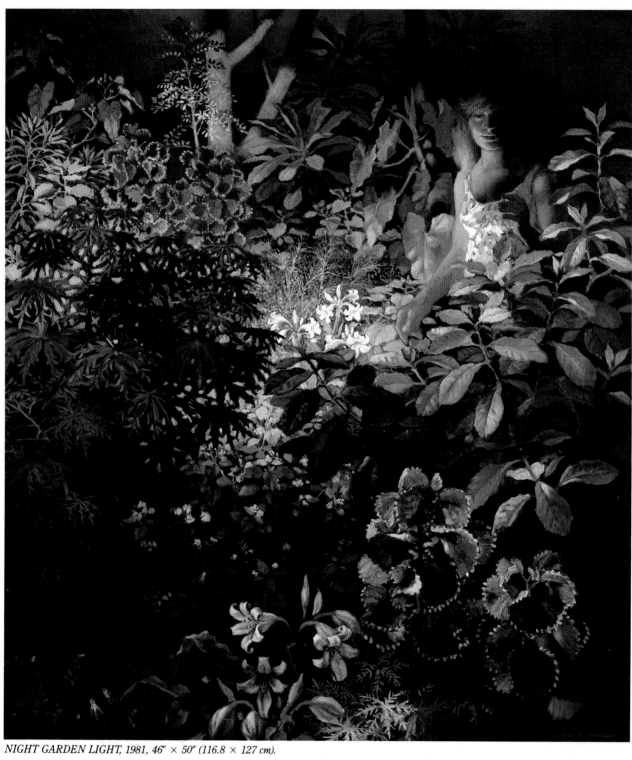

NIGHT GARDEN LIGHT, 1981, 46" × 50" (116.8 × 127 cm).

INTRODUCTION

I love painting. I can become very bad-tempered when an image doesn't work, but painting, and the drawing that precedes it, is what I want to do all the time. I don't dread a blank canvas, as some artists are said to do—I feel it's an exciting challenge, like embarking on a voyage to an unknown exotic country.

Draftsmanship, painting technique, and an understanding of value, color, and composition are all elements of making a good painting. Equipping yourself with these skills gives you freedom to do what you want in this uncharted territory. For you to soar into the skies of your own creative imagination, you must have the wings of basic practical knowledge. In addition, it's amazing how, as you master a craft, ideas spontaneously develop. Knowledge often ignites invention.

Of course, simply accumulating skills may produce nothing more than a competent painting. Nevertheless, it is surely better to make a competent, uninspired painting than to make an incompetent, uninspired one.

Great paintings can fail lamentably in one area—for example, the awkward or even poor drawing in some of Gauguin's or Van Gogh's work—yet they are still marvelous paintings because of the intangible spirit that informs them. There is great danger, however, in the arrogance of thinking your vision is so powerful that you don't need to know how to paint. I think painters should have the ambition to be great artists but also the humility to accept criticism with grace. Of course, you don't have to follow the criticism, but you should think about it. Keep your mind open, and don't think that the ordinary layman, who knows nothing of art vocabulary or theory, cannot make valuable comments about your work. These comments may, in fact, be surprisingly useful just because they are unaffected by current art styles and opinions. I find that famous expression "I don't know anything about art, but I know what I like" a very reasonable remark. A layman may indeed like what he or she likes for emotional rather than aesthetic reasons. But you, as the creative person, can consider the comment to see if it has any validity for you. You are the final judge; you must do what pleases you in your own unique way.

During my seventeen years of teaching painting classes at the City College of New York, I used to make private bets with myself at the start of each term as to who would do well and who would be a disaster—and *I was always wrong!* The students who did astonishingly well were often the worst in the beginning, but their passion to learn, their enthusiasm and excitement over what they were doing, opened all the creative doors to them. By contrast, my biggest disappointments were the talented students who were overconfident at seeing how much better they were than the novices. Often resenting advice ("I always paint like this"), they went nowhere. Although they did not really think they were going to be important artists, they still didn't want criticism. To me that is completely the wrong attitude.

I do not believe in any dogmatic prohibitions or exhortations about art. Every so-called absolute is broken by the inventive artist charting out new territory. Now, there I've gone and made an absolute myself, which I must hasten to correct. You don't *have* to chart out new ground. You can be as traditional as you like and be a great artist, but it all should be fresh and enthralling to *you*, as you build on the past, equip yourself with as much competence as possible, and release yourself to say and paint anything. I hope this book will help you to do just that.

This book, then, is intended to give you an overall view of how to create a figurative painting. It starts with practicalities and moves on the creative and aesthetic. The first two parts introduce you to the basic building blocks of your imaginary edifice, blocks that can be used to make any sort of structure but without which the structure is likely to collapse. Or you can consider this information the keys to unlock your own artistic potential. Part 1 deals with the problems of drawing the face and the figure. Part 2 covers the essential materials, techniques, and principles you will need for painting.

In Part 3 we'll move into the aesthetic domain, where we'll develop an idea together, experimenting in different ways with a simple composition of a woman's head. In the making and changing of this painting, you'll discover almost limitless possibilities in the variations of color, mood, and design—even size and proportions.

Part 4 is a diary of the development of two of my own paintings. Part 5 is a commentary on several of my completed works. They are not examples of how you should paint but keys to unlock your imagination. I hope they may act as catalysts to start you on your journey into your own artistic unknown and your creation of your own visual world.

PART 1

DRAWING FOR PAINTING

A composition with figures can be created in any medium—pencil, charcoal, pastel, watercolor, oil—although in this book I have concentrated on oil painting. Whatever medium you choose, the basis for all figure work is understanding how to construct the figure. As a painter, you should be able to create figures in any pose you choose. You will probably want to pay particular attention to that most fascinating area of the figure, the face, and to those complex extremities, the hands and feet.

The ability to draw is of inestimable value to your painting because it releases you from stumbling around trying to get the figure right when you have so much else to grapple with—composition, color, painting technique. Many painters, however, lack an understanding of the figure and have never developed the ability to draw because there are such dreadful gaps in much art instruction. Some avant-garde teachers reared on a diet of artistic theory and ideology overlook whole areas of practical information on elementary principles of drafts-

manship. Their students, even if otherwise brilliant, flounder in a wash of vague ideas and wonder why they don't improve. In this part I'll provide such information, proceeding from linear diagrams to full drawings. These illustrations are not ways you yourself should draw but aids to help you understand what you see.

I've used a simple medium—black pencil on white paper—at the beginning; then I have gradually used more complex and seductive materials, such as colored pencil and pastel on tinted paper as a transition to oil paint, which is a jump but a logical one.

Novices generally make the same mistakes, such as failing to align the parts of the figure correctly or squeezing the eyes too close to the nose. But if you follow this discussion and understand it, you will be able to find out why your drawing or painting looks peculiar or why a likeness is poor. When you can identify an error, you can correct it.

Skill gives freedom. Persevere in gaining skill and you will do infinitely better than you ever dreamed possible.

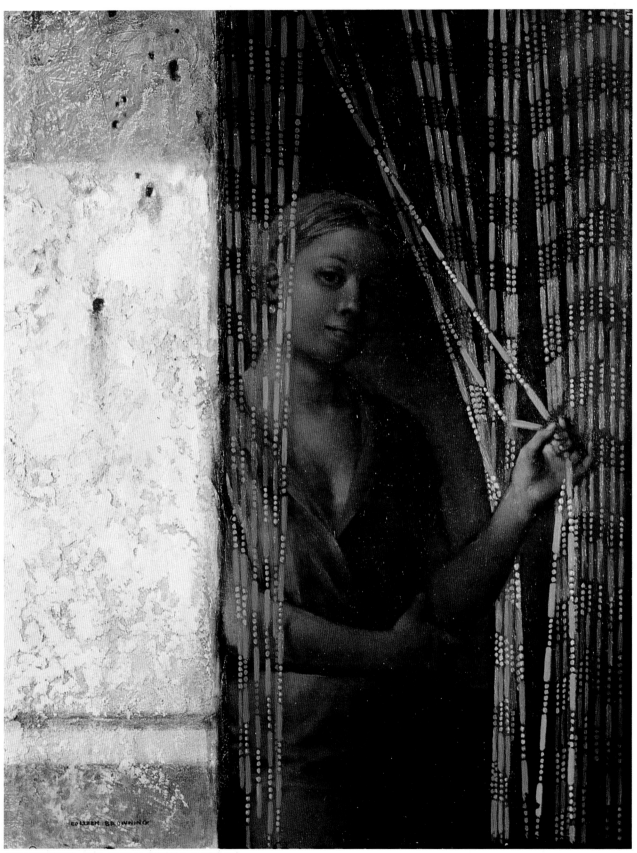

ITALIAN GIRL, 1959, 17½" × 22" (44.4 × 55.8 cm).

PRELIMINARIES

Before settling down to the specific problems of depicting the face and figure, we should first consider the use of models and my own working procedure.

MODELS

If you have a good model, you will find it much easier to study the face and figure. For figure painting I advise using professional models or at least someone who has posed before. You might use a student, an artist friend who understands what you are doing, or an out-of-work dancer. Dancers are marvelous models because they know how to use their bodies as works of art and have great muscle control. Many other people, however, are surprisingly nervous at being looked at intensely. They may twitch or giggle, tire easily, or even feel faint. If you have an inexperienced, nervous model, that will disturb you, especially if you are a bit nervous yourself, so that you will not be able to concentrate.

For portraits, however, you can use a friend who will sit calmly, although even a friend may be a bit tense at first. Whoever your model is, one you like personally is always much easier to work with than one who irritates you, even if he or she is a good model.

Where do you find models? Unless you are affiliated with an art school or college, that is not too easy. I would suggest going to a sketch class for a while and making contact there with any model you particularly like. Of course, if the registrar or model secretary of an art school knows you personally, he or she can give you names, and you have a reference. People today are generally leery of going to pose at a stranger's house or studio without having bona fide references for the artist.

Many years ago I wanted a Hispanic model for a painting of a madonna, so I advertised in a Spanish-language newspaper. Before accepting the ad the editor called me to check on my credentials. I think he was quite right to do so.

Artists' models charge a higher fee per hour to pose privately than they do to pose for a class, so you can't go by an institution's fees as a guideline.

Avoid giving the model a strained pose with an exaggerated twist of the head, torso, or limb. The model will tire easily and gradually fall into a more natural position, with the result that you may start with one pose and end with another.

In portraits, use comfortable combinations of frontal and three-quarters views of the head and shoulders. If the model is a woman, ask her to remove any heavy lipstick and eyeliner, as it will interfere with your understanding of the underlying forms. Don't ask the model to smile; it will turn into a strained grimace. Give him or her a rest every twenty-five minutes.

When I am making sketch notes from a model for a painting, I find it more helpful to start a new drawing each time the model resumes the pose after a rest. If it's a simple pose, you could go on with the same sketch, but it's amazing how many variations creep in each time the pose is resumed. I rather like this, as each new sketch of the same pose gives me a new possibility to consider using later in the painting.

HOLDING THE PENCIL

With a razor or knife, cut a pencil all around and snap it in half, to make two smaller pencils. The smaller size encourages you to draw more flexibly instead of "writing" your drawings. Hold the pencil in the drawing position—that is, between the thumb and forefinger, with the end of the pencil inside the palm. However,

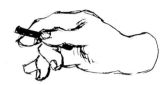

The correct way to hold the pencil is between thumb and forefinger, keeping the end of the pencil inside your palm.

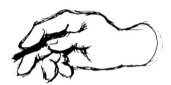

Use the writing position for rendering fine details.

when you need to concentrate on fine details, go back to the regular writing position, with the end of the pencil pointing up.

POSITIONING YOURSELF AND YOUR PAD

When you are drawing the head and face, sit close enough to your model to see all details clearly, about three feet or less, but don't sit too close to your drawing, lean over your pad, or peer at it too closely. If you do, you are likely to slip into errors that you could easily spot if you were looking from a greater distance. Keep rearing back from your pad to check your drawing and the model from farther away.

When you are drawing the whole figure, you will, of course, be farther away from the model than when you are drawing a portrait. You need to see the whole figure, not just the face. The closer you are to the figure, the more you will get a top view. I strongly recommend standing up and drawing with your arm extended. Stand away from the drawing frequently in order to estimate proportional relationships correctly. Beware of making the legs too short and the

feet too small. This is a common error that creeps in easily if one's arm movements are constricted because the arm is held too close to the body.

You should have your pad or drawing board propped up at an angle so that the top is higher than the bottom. If you are sitting, the whole pad should be at a right angle to your line of vision. If you are standing, the angle can be less acute because you are already at a distance from the paper and can see the figure as a unit. If your pad or board is flat, you immediately risk introducing false perspective into your drawing because anything on the bottom of the page, being closer to you, will look larger than anything at the top, which is slightly farther away.

Don't draw too small, or you will have a dark, smudgy, "worried" little drawing. Students generally draw too small, hoping that their errors will be small, too. Don't draw too large either, or you will have difficulty in estimating correctly the distances between points of reference, such as eye to ear or nose to mouth on a portrait.

The size of your drawing should be related to the size of your drawing implement. With a hard pencil or a pen on hard paper, you can draw quite small. But if you are doing a portrait, don't make the head less than 4 inches. With a soft 6B pencil, you should make the head at least 6 inches. If you use pastel or charcoal, which form a wider line on paper, you must draw large enough to avoid having a congested image. But keep the drawing under life size. I always like a big pad, 18 × 24 inches, with a smooth white surface because it allows me to draw large or small depending on what medium I want to use. I think small pads encourage small, "anxious" drawings, and I have a prejudice against newsprint because it takes few mediums and turns brittle and deep yellow with age.

For figure drawing, a standing position provides a better view of the model. The pad or board should slope toward the artist.

Looking at a drawing in a mirror gives a reverse image, which is likely to reveal errors that would otherwise escape notice.

Don't be anxious and keep on rubbing out your "mistakes." Some students start rubbing out almost before they have made a mark on paper. It is often interesting to observe how an artist's mind works when you see corrections drawn over errors.

VIEWING YOUR WORK

It is important to see your drawing from a distance while you are in the process of working. In addition to rearing back from your pad if you are sitting, or standing back from it if you are on your feet, you should also check it in a mirror. This will mean turning your back on the model and looking at the drawing and model in reverse. You will be astounded at how many errors you notice! When you turn back to your drawing, remember that what was left in the mirror is right in your drawing. In a portrait, to locate which side is which, it helps to notice the line of a hairstyle or a part or some other marker such as a scarf or pin. If you never see your work from a distance until you are finished, you may have a disagreeable surprise.

THE FACE AND HEAD

Since the face is the most complicated part of the figure and the area that attracts most attention, we'll concentrate first on the head and face.

RELATING THE HEAD AND NECK

Always think of the head in relation to the neck and shoulders, which are also part of the character of your model. When you are doing a portrait, you don't have to show all the shoulders, but you should indicate that there is something below the neck; maybe just a collar will be enough.

The head and shoulders can swivel and bend in different directions to each other, but they are always linked by the cylinder of the neck. If you don't bear in mind that these are three flexible elements, you tend to show them as one rigid unit.

You can think of the shoulders as a wire coat hanger, with the bottom bar representing the collarbone. Notice that the pit of the neck comes well below the shoulder. The shoulders slope down from the base of the neck; they don't make a sudden right angle with it.

In profile and three-quarters view, notice that the neck continues the line of the head at the back, but it is recessed under the projecting jaw in front. If you don't recess the neck, the head looks as if it can't swivel, like a knob on top of a stick.

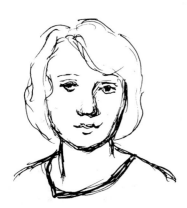
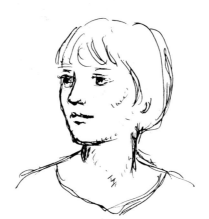
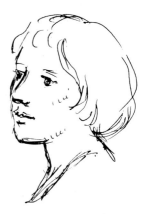

The head can turn in a different direction from the shoulders: a frontal head on three-quarters shoulders (left), a three-quarters head on frontal shoulders (center), and a three-quarters head on shoulders in profile (right).

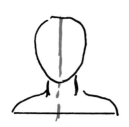
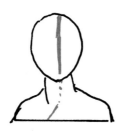
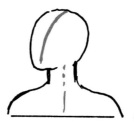
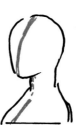
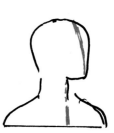

The head is linked to the shoulders through the cylinder of the neck.

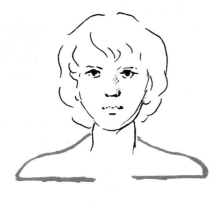

The shoulders can be diagrammed as a wire coat hanger whose bottom bar stands for the collar bone. The pit of the neck comes well below the shoulder.

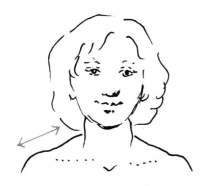
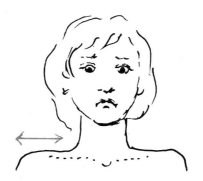

The shoulders slope from the base of the neck (left); they do not form a right angle to it (right).

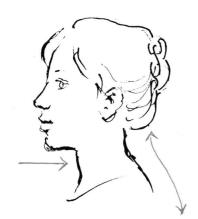
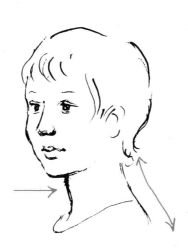

In profile and three-quarters views the neck and the back of the head form a continuous line. The neck is recessed under the chin.

If the neck is not recessed under the chin, the head looks like a knob fixed in place on top of a stick.

The Face and Head

DIFFERENT VIEWS OF THE HEAD AND FACE

The head and face are not flat but a three-dimensional shape curved in subtle planes. You might think of them as a sort of rounded box. The way you draw them depends on the angle from which you view them.

FRONTAL VIEW. In a frontal view the face appears symmetrical, so imagine the features as placed on a grid of horizontal and vertical lines. Every feature or part of a feature on one side of the face has to correspond to its mate or other half on the other side. This imaginary grid can tilt in any direction—left, right, forward, back—but the horizontals are always at right angles to the verticals. They cannot be out of alignment. If you lose this right-angle grid, the features tend to slip out of place, and the face will look wrong.

When the head is bent forward, or lowered, the horizontals of the imaginary grid appear curved, and you see more of the scalp and forehead and less of the chin. When the head is tilted back, or raised, the horizontals of the grid appear curved in the opposite direction. You now see the space under the chin, under the nose, and under the eyebrow, and the forehead and nose are greatly reduced.

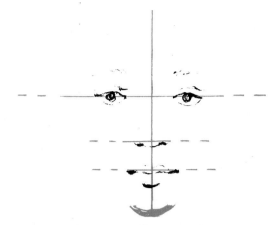

The features are arranged symmetrically on a grid.

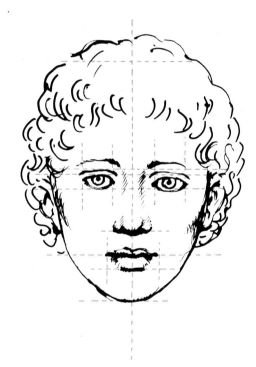

Since the face is symmetrical, every feature or half feature on one side of the central vertical of the grid must correspond to the other one of the pair or other half on the other side.

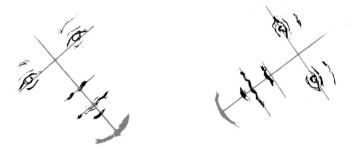

The grid can be tilted, but the horizontals and verticals are always at right angles.

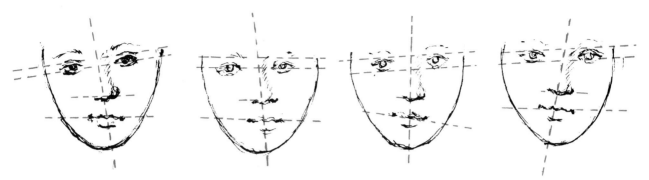

If the features are not accurately aligned on the grid, the features will slip out of place.

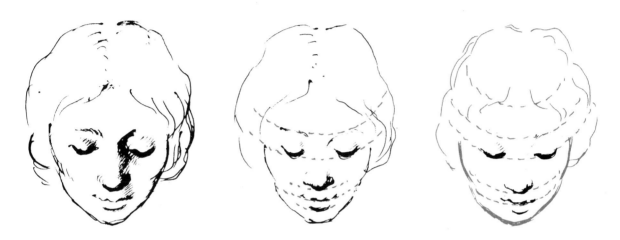

A lowered head shows more of the scalp and forehead than of the mouth and chin.

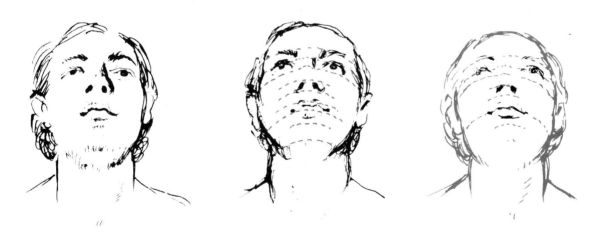

A tilted head shows the underside of the chin, lip, nose, and brow and a much reduced forehead.

The Face and Head

THREE-QUARTERS VIEW. In a three-quarters view, the boxlike shape of the head is clearly evident. You are aware of the front plane and the side plane at the same time. The imaginary grid remains intact but with this difference. The length of the features on the far side, turned away from you, is shorter, but not higher, because you see less of the face on the far side and because of the curve of the features. You see much more of the face—more than you think—on the near side because you see both front and side planes and the side of the head and the hair. There is always a tendency to put the near eye too far forward, which brings the cheekbone forward, losing the front plane of the head, and the ear too far forward, reducing the side of the head. Overlooking the right angles of the grid is the primary fault of all drawings of the face and head, especially in a three-quarters view.

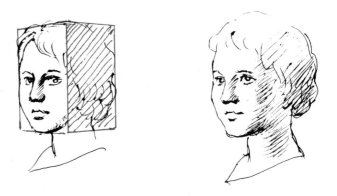

Three-quarters views reveal the boxlike structure of the head.

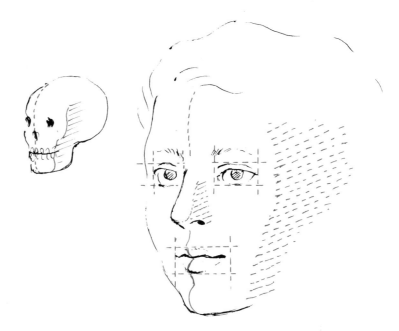

In three-quarters views the features on the far side of the face appear shorter than those on the near side.

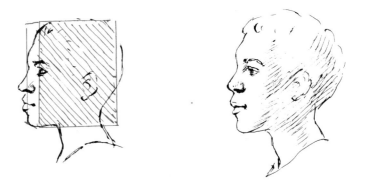

In a profile view, you see much more of the side plane than the front plane.

PROPORTIONS

Understanding the proportions of the face will help you achieve a realistic likeness. An inexperienced student is inclined to place the eyes too high, which throws the rest of the features out of proportion. In the average person, the eyes are at the midpoint of the head. The tip of the nose is halfway between the eyes and the chin. The line of the mouth is halfway between the nose and the chin. In the upper part of the face, the hairline is about halfway between the eyes and the top of the head. Once you have these average proportions firmly in mind, you will begin to notice the slight variations that make each person a distinct individual.

An inexperienced student is likely to place the eyes too high in the head.

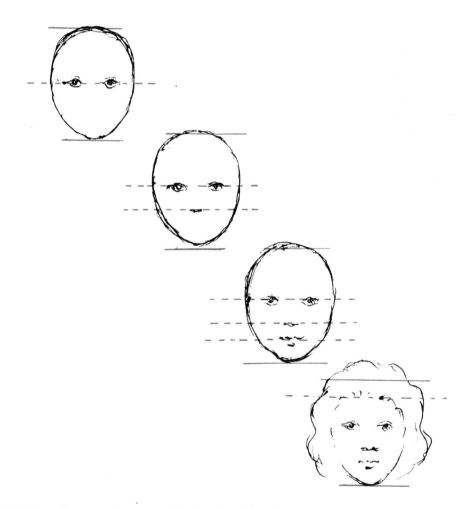

The eyes fall halfway between the crown of the head and the chin. Below the eyes, the end of the nose is halfway to the chin. The line of the mouth is halfway between the nose and the chin. Above the eyes, the hairline is halfway to the crown of the head.

The Face and Head

THE EYE

When drawing the eye we need to consider both its structural elements and its placement in relation to the other features.

STRUCTURE. The eye is not a slit in a mask but a globe held in place by muscles and fleshy eyelids. Always think of it as being inside the eyelids. Most students omit the eyelids or show only traces of them. This mistake changes the whole appearance of the face. It places the eyebrows too close to the eyes and makes the forehead too low.

In a frontal view you can see three lines above the pupil formed by the lash line, the eyelid fold, and the eyebrow. The thickness of the upper lid is generally masked by eyelashes, but you can see the thickness of the lower lid like the edge of a thick saucer. In a three-quarters view you will see the actual thickness of the upper lid.

The upper eyelid varies in prominence with each individual and in how much of the pupil it covers and is therefore important in achieving a likeness. It may cover the pupil only slightly, or cover a third of the pupil. The shape of the eyelid is also important in capturing a likeness. It may be fleshy, deep set under the brow, or drooping at the outer corner.

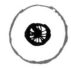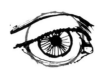

The eye is a sphere held in place by the eyelids.

The eye is always contained within the eyelids.

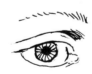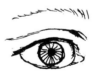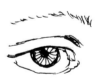

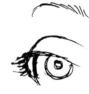

A frontal view shows three horizontal lines: the lash line (bottom), the eyelid fold (center), and the eyebrow (top).

A three-quarters view shows the thickness of the upper lid.

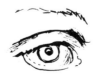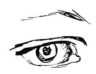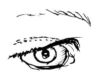

The pupil may be slightly covered by the upper lid (left), evenly spaced between the lids (center), or one-third covered by the lid (right).

An element in portraying character is the shape of the upper eyelid, which may be fleshy (left), deep set (center), or drooping (right).

PLACEMENT. When drawing a frontal view, always allow the length of an eye between the eyes. More than this normal space gives the effect of wide apart eyes; less makes the eyes appear close set.

Placement can be tricky in a three-quarters view. Be careful not to put the eye on the near side too close to the nose or the one on the far side too far from the nose. The nose covers the inner corner of the far eye. Also beware of drawing a frontal view eye in a three-quarters face.

When the head is in profile, you see only half the eye, as you see only half the face. Do not forget to show the thickness of the eyelid. Always place the eye in the eye socket in the plane of the face, not on the side of the nose.

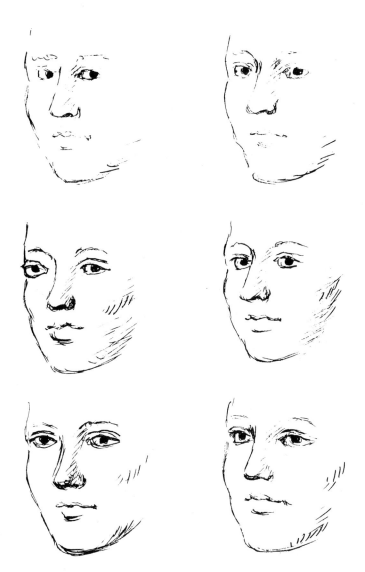

There are many common errors in placing the eyes, as can be seen in the sketches on the left and their corrections on the right. The eye on the near side can be too close to the nose (top left). The eye on the far side can be too far from the nose (middle left). A frontal-view eye is incorrect in a three-quarters face (bottom left).

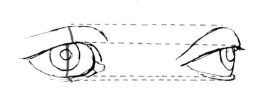

When the head is in profile, you see only half the eye.

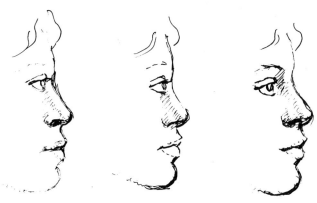

In a profile the eye should not be too far forward (left) or on the side of the nose (center) but should be back on the plane of the face (right).

The Face and Head

THE NOSE

You can think of the nose diagrammatically as an expanding, projecting wedge shape with three planes—two sides and a front. In a frontal view if you ignore the side planes, you will put the eyes too close together. In a profile or three-quarters view, if you ignore the side plane, you will put the eyes too far forward, as if they were painted-on spectacles.

Consider the area between the nose and the mouth as two triangular shapes linked by a depression. If one side of the nose is shadowed, then the triangle below the nose on that side will also be shadowed. If one side of the nose is lit, so also will be the triangle below it. But because the angle of slope on the side of the nose is steeper than the angle of the triangle, the lights and darks will be less strong.

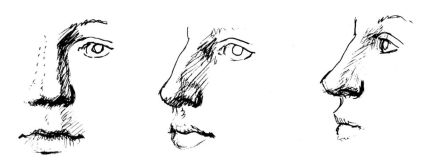

The nose forms a projecting wedge with two sides and a front plane.

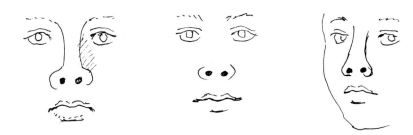

Two curved lines are not an effective way to draw the nose because they ignore its three-dimensional form.

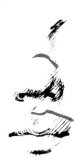

The area between the nose and the mouth forms two triangles connected by a depression.

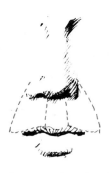

If one side of the nose is in shadow or light, the corresponding triangle between nose and mouth will be in shadow or light but less strongly.

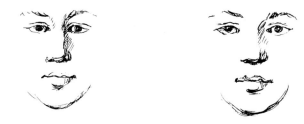

In a frontal view, if the side planes are not depicted, the eyes will be too close together (left) instead of properly spaced in their sockets (right).

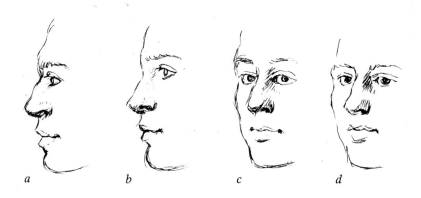

a b c d

In a profile or three-quarters view if the side plane is not taken into account, the eyes will be too far forward (a and c) instead of back in their sockets in the plane of the face (b and d).

THE MOUTH

Do not think of the mouth as a flat shape. It consists of three elements: (1) the line between the lips; (2) the upper lip, which recedes; and (3) the lower lip, which projects and is defined by the recession under it. If you can think of the area below the nose as a series of surfaces moving in and out like corrugations, you will capture the facial structure of your model.

In a three-quarters view, the mouth, like the eye, changes shape on the far side of the face because you see less of the face on that side and because of the curvature of the facial forms. The length and the curve change, not the height, as all the reference points on the imaginary grid have to be touched in a shorter space. If you make the far side of the mouth too long or too large, the lips will look swollen.

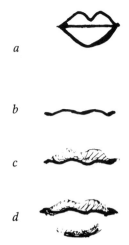

a

b

c

d

The mouth is not a flat shape (a) but is composed of three parts: the line between the lips (b), the receding upper lip (c), and the projecting lower lip (d).

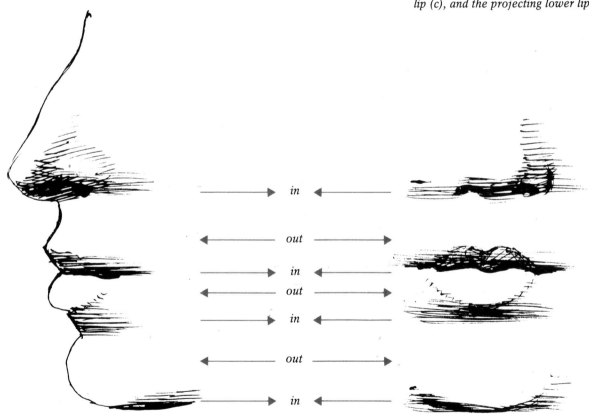

in

out

in

out

in

out

in

The area between the nose and the chin moves in and out like a series of corrugations.

The Face and Head

MODELING THE FACE

There are various ways to emphasize the modeling of the face so that it is not just a flat blank expanse with features.

MODELING WITH LINE. You can achieve modeling with line. A line stops the eye. Therefore, you can use a line to separate one form from another such as the line between the lips, the line between the eyelid and the fold above it, and the line between the edge of the nose and the far cheek in a three-quarters view.

MODELING WITH LIGHT AND SHADOW. Another way to model the face is by a combination of light and dark areas to indicate a change in the direction of the facial planes. Under normal lighting the recessed areas of the face tend to be darker and the projecting parts lighter. Generally light comes from above eye level, for example, sun-light and most artificial light. The only time it comes from below is when reflected light is bouncing off the floor or clothing or when the model is bending over a light. Light coming from the side produces the most emphatic contrasts. Adjust the lighting on your model to emphasize the facial planes.

To indicate light areas, leave the paper white. Shade the darker areas by covering them with hatching (series of fine parallel lines), cross-hatching (fine lines crossed at

Under normal lighting conditions, the recessed areas of the face tend to be in the shadow and are darker; the projecting parts tend to be in the light and are lighter.

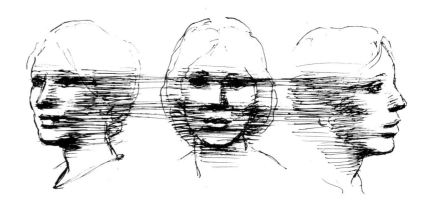

Adjust lighting to help you see the facial structure of your model. Emphasize those areas where there are strong projections or recessions.

an angle), or even a fine scribble. In cross-hatching the lines can cross at any angle but be careful not to make it a right angle or it will give an even texture that suggests a textile. The eye slides over a hatched area whose lines suggest a plane turning in one direction on to an adjacent area where the hatching either stops or goes at another angle, indicating a plane going in another direction.

You can model the face by hatching with lines so close to-gether that they form almost a solid gray. You can deepen the modeling by building layers of hatching and cross-hatching. You can further blend the lines in a large area by rubbing over them lightly with the tip of your finger. Be cautious, however, in using your finger in small areas or you will make shapeless smudges.

Students often confuse lines and planes when drawing faces, using lines, which make even a young person look haggard, instead of directional planes. Most of the lines that an artist uses to draw the face are in fact sudden changes in plane. They are meant to convey a transition from one plane to another and shouldn't translate as wrinkles.

As people age, the flesh starts to sag, and loose folds of flesh form wrinkles or bags, giving a very different effect from the smooth, uninterrupted contours of youth. You show these aspects of the face as folded planes indicated by a sloping kind of hatching.

You can model the face by using either hatching or crosshatching, or both, so that the lines are so close together that they form a tone—almost a solid gray.

You can further blend the lines in a large area by rubbing over it lightly with the tip of your finger.

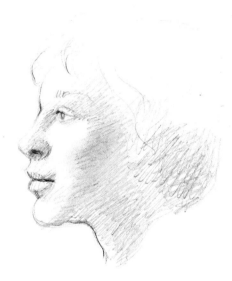

Be very cautious when using your finger to blend small areas, such as in the cheek area seen here, or you risk the possibility of making shapeless smudges.

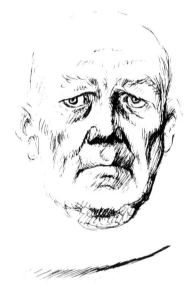

A sloping or slanting type of hatching turns into a solid line where wrinkles compress into folds.

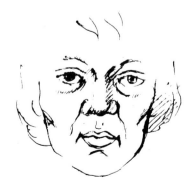

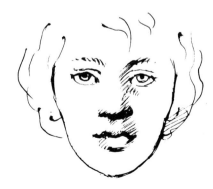

As seen in the face at left, a confusion of line and form creates a haggard effect, even in young people.

THE FIGURE

Deliberate distortions of the figure for expressive effect are one thing. Incompetence is another. In this section we'll consider some of the basic errors in figure drawing that crop up over and over again, not only in students' work but often in that of many artists.

PROPORTIONS

The proportions of the parts of the figure vary enormously. Since you are a creative artist, you may exaggerate or reduce at will, for expressive purposes. Nevertheless, it helps to know what average proportions are so that you distort intentionally rather than slip into the habit of unwanted "mistakes."

(Let me emphasize here that a work of art is not good by its absence of mistakes but by its positive virtues; a good, even a great, painting can absorb a large number of "mistakes.")

Acceptable or ideal proportions vary from age to age. The ancient Greeks considered a very small head admirable because they thought it gave dignity to the figure. In modern times the ideal size of the head in relation to the body has greatly increased, possibly because of our emphasis on the individual.

Taking the length of the head as a measuring unit, an "average" figure, is divided into six and a half heads. There are three heads from chin to groin: one from chin to nipple, one from nipple to navel, and one from navel to groin. There are three and a half heads from groin to heel: one and a half from groin to knee, one and a half from knee to ankle, and a half head from ankle to heel. The arm is about three heads long from the shoulder to the tip of the middle finger. The hand is the size of the face from the chin to the hairline.

The tendency in drawing a figure is to enlarge the parts that interest you and reduce the others. Thus a drawing might have a large face and tiny feet, or gigantic breasts drawn by a student who has never worked from the nude before. I like models with short legs, so my figures are often less than three heads from groin to heel.

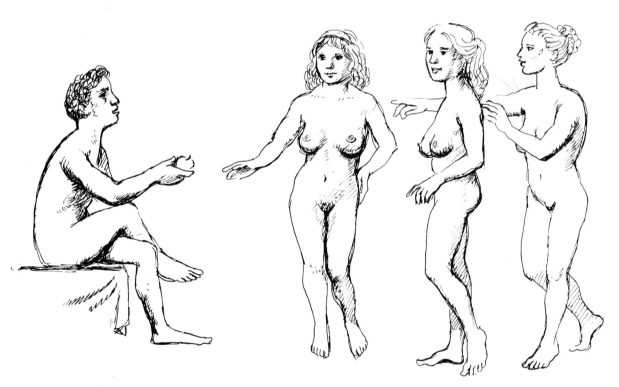

The above is a collection of common figure drawing errors: The seated male figure's head is much too small at the back, which distorts the placement of the ear. His head is also much too large for his torso and legs. The back of the man's neck does not make a smooth connection with the continuous curve of the spine; and jaw, neck, and chest are just one rubbery form. The left foot is a shapeless band. The frontally facing female figure's upper body overwhelms her lower body. Her torso gradually diminishes into too short legs ending with feet that do not rest naturally on the ground. The central female figure has much too large a head for her body. She has lost her torso between breast and buttock—a common drawing error caused by the confusion of the crossing arm. She also has an undulating right foot. The female figure at far right is flawed by a muddled and fused back and shoulder line—which is neither one nor the other—and by an awkward neck connection.

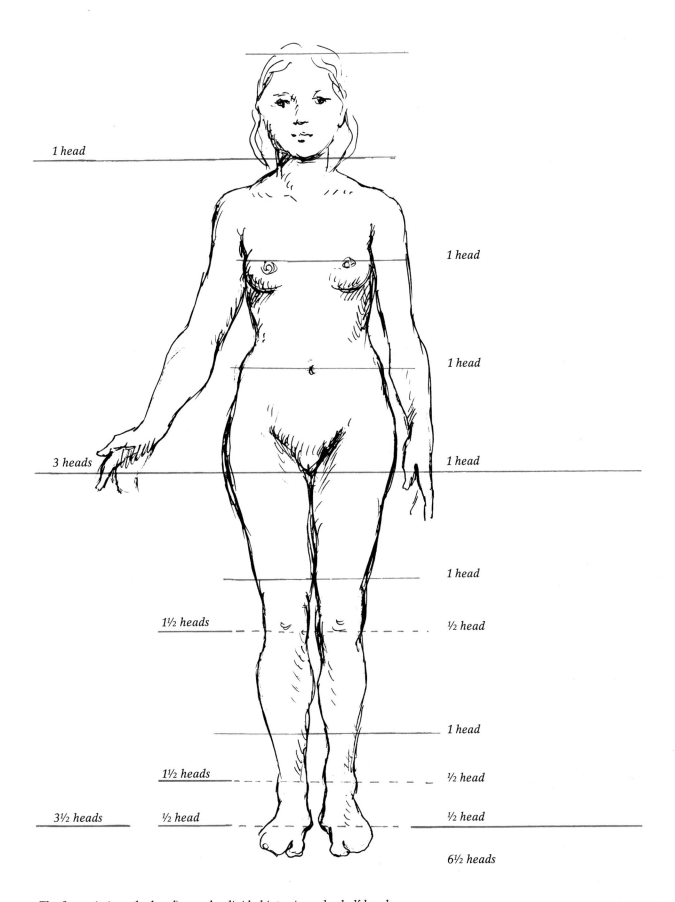

1 head

1 head

1 head

3 heads 1 head

1 head

1½ heads ½ head

1 head

1½ heads ½ head

3½ heads ½ head ½ head

6½ heads

The figure (minus the head) may be divided into six-and-a-half heads.

The Figure

THE BACK

An area that causes some problems in a profile figure is the back. You should think of the backbone as extending in a continuous curve up to the skull. The neck is *not* a separate affair. If you always carry the line of the bent back up through the back of the neck, you'll avoid making a hunchback with a dislocated neck.

The head is heavy and naturally falls forward if the back is bent. See for yourself how uncomfortable it is to lean over and raise your chin. In fact, a good way to check the position of a figure in a painting that looks peculiar is to try to take up the identical pose yourself and observe yourself and the drawing in the mirror.

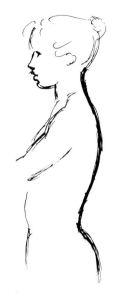

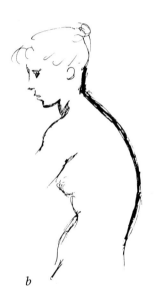

In profile the neck and the back form a continuous line.

The line of the neck flows out of the line of the back (a and c); it does not jut off at a sharp angle (b and d), making the figure look hunchbacked.

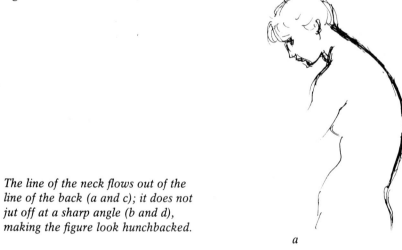

a

b

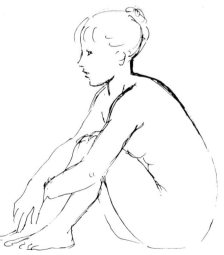

c

d

THE LEGS

When drawing legs from the front or back, observe the diagonals from the outside to the inside. Notice that the inside bulge of the lower leg is lower than the outside bulge, but the inside ankle is higher than the outside ankle. When the legs are parallel, these diagonals, if connected, give you an imaginary X. If you can keep in mind the subtle diagonals in the legs and ankles, you'll avoid drawing legs with rigid sticklike effects.

When drawing legs in profile, it helps to think of the underlying shape as an elongated S or a reversed S, depending on which way the legs are facing. Or you could think of the front of the upper leg as a convex curve that crosses over at the knee to become a concave curve at the back of the lower leg. Then you will avoid making legs that look like sausages or poles.

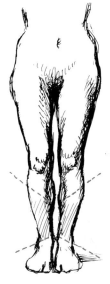 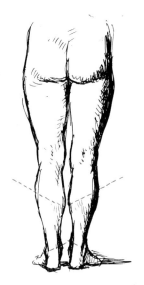 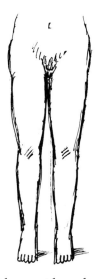

In a frontal view diagonals can be drawn on the lower leg from the outside bulge to the inside bulge and from the inside ankle to the outside ankle. When the legs are parallel, the four diagonals form an X.

In a back view the same diagonals can be drawn across the lower leg and ankle as in a frontal view.

Legs that have not been drawn with the diagonals from inside to outside in mind are likely to resemble posts.

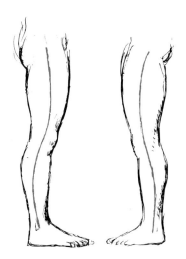 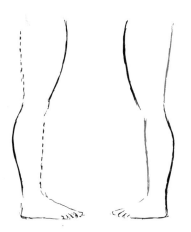 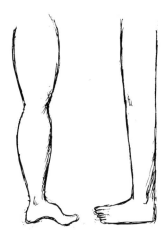

Legs in profile may be diagrammed as an elongated S curve or a reverse S curve.

The front of the leg forms a convex curve that crosses at the knee to form a concave curve along the back of the leg.

Legs that are drawn with the idea of S curves or convex-concave curves in mind will not resemble sausages or posts.

The Figure

THE FEET

Another problem area is feet. Seen from the front, a foot seems to be contained within a pyramid shape with one corner removed. If you think of the foot this way, you avoid ending the leg in what looks like a fringed ribbon. When drawing the foot in profile, I've found it useful to see it as fitting into a wedge shape, which forms a firm base to support the body. Those undulating shapes or horizontal strips that inexperienced draftsmen make couldn't support anything.

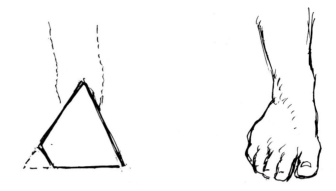

The foot seen from the front may be diagrammed as a pyramid with one corner missing.

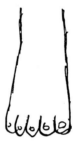

A foot that is not imagined as a pyramid is likely to look like a fringed ribbon.

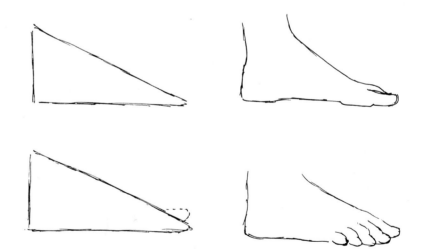

A foot in profile forms a wedge, which provides a solid base for the body.

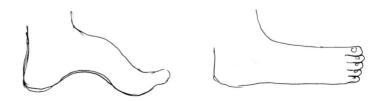

A foot that looks undulating or like a flat band could not support the body.

THE HANDS

I think one of the reasons that hands drawn by inexperienced students often look like an awkward bunch of bananas is the lack of cohesion of the fingers and the lack of a palm—the fingers seem to spring from the wrist. I find it useful to think of the hand in all positions as a mitten. From this simple shape (one thumb and all the fingers in a lump) you can separate out the fingers you wish. The mitten seems to preserve the unity of the hand while allowing variety for the fingers.

To draw a curled or clenched hand, establish the series of changing planes by using light, middle, and dark values. Don't forget the wrist. This unobtrusive but very important junction between the hand and the arm gives the hand elegance and flexibility.

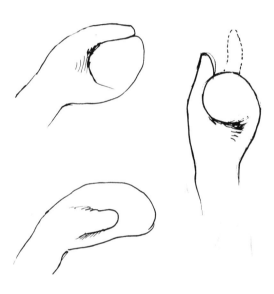
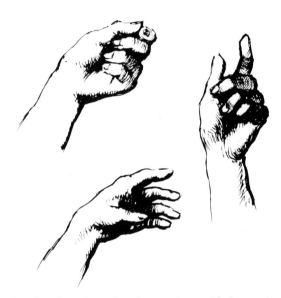

The basic shape of the hand is a mitten with a separate thumb and all the fingers bunched together.

Any hand can be reduced to a mitten with fingers separated out as the pose requires.

A hand with a clearly defined wrist looks more flexible and elegant.

COSTUME

Unless you are painting nudes, you will want to show your figures clothed. Often, however, the folds seem so confusing that you either overlook them or settle for a vague mess of lines. Instead, you should consider costume as a further possibility for design as well as a subtle indication of the thrusting form underneath. You can explain a whole figure by the way folds drape it without showing one inch of flesh. Make sure the model is inside the clothes and reflects the underlying form in the contour.

A confused understanding always produces a confused image. So, in this section you will be introduced to the structure of folds. It is a fascinating subject and not as difficult as you might imagine, once you take interest rather than resenting the complications.

There are several points to remember:

The first is that folds recur in the same basic shapes over and over again, regardless of the material. They hang straight, pulled by gravity, unless they are interrupted by the thrust of the form underneath. As they fall, they gradually expand so that each original single fold dents into two folds forming a fork, or a Y shape. This fork or Y is the basic structure of all folds, but it can vary in width, direction, and combination.

All materials from silk to cotton, canvas to leather, have this fork structure, but stiff materials make larger and more sharply angled folds. Softer materials make smaller, more rounded folds.

The second thing to remember is that folds are three-dimensional. They are not slits or wrinkles but have tops and sides. When a fold is compressed, one or both sides may

be drawn as a line, but as soon as the fold expands, both sides should be drawn as planes.

The best way to understand folds is to drape a large towel over a chair in different ways and make a lot of drawings. You will soon start to recognize the basic structure and recurrent shapes. If you get muddled as to which fold you are drawing, as often happens, count

down or across 1,2,3 . . . on both towel and drawing until you are oriented.

When you are making drapery studies, you'll have to make a new drawing each time the model moves, but the folds will always conform to similar configurations in the same area. Just make several drawings and combine what you need for your painting.

The figure should fit inside its clothes (left). They should not look pasted on (right).

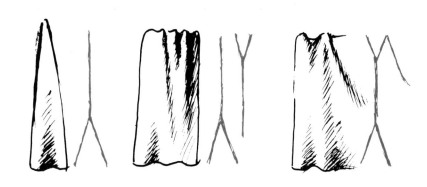

A fold grows wider as it falls, eventually forking into two folds, diagrammed as a fork, or Y.

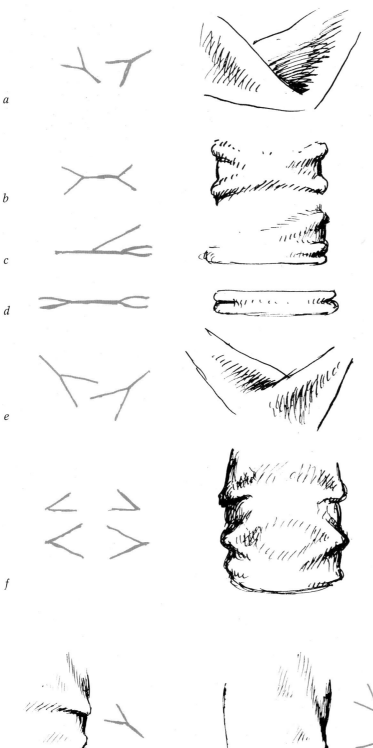

These examples of diagonal and horizontal folds might be seen in sleeves, blouses, or shawls. The folds fall into recurrent shapes such as two open forks combined (a), two open forks joined (b), a closed fork with a branch (c), double closed forks (d), another version of two open forks combined (e), and a series of open forks (f).

a

b

c

d

e

f

The characteristic fork shape may be seen in the folds of sleeves.

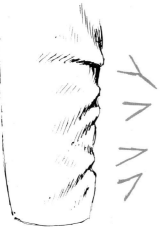

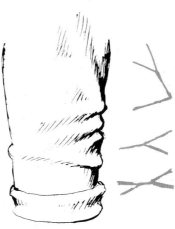

Costume

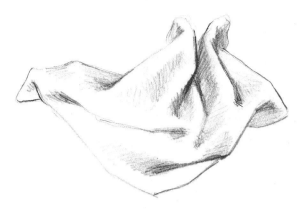 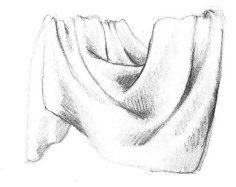

Heavy, stiff material tends to fall into large, angular folds. *Soft material tends to drape in smaller, more rounded folds.*

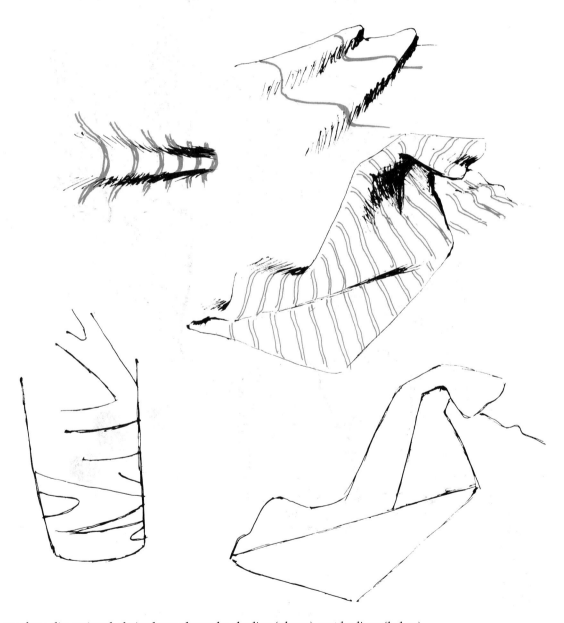

Folds are three dimensional, their planes shown by shading (above), not by lines (below).

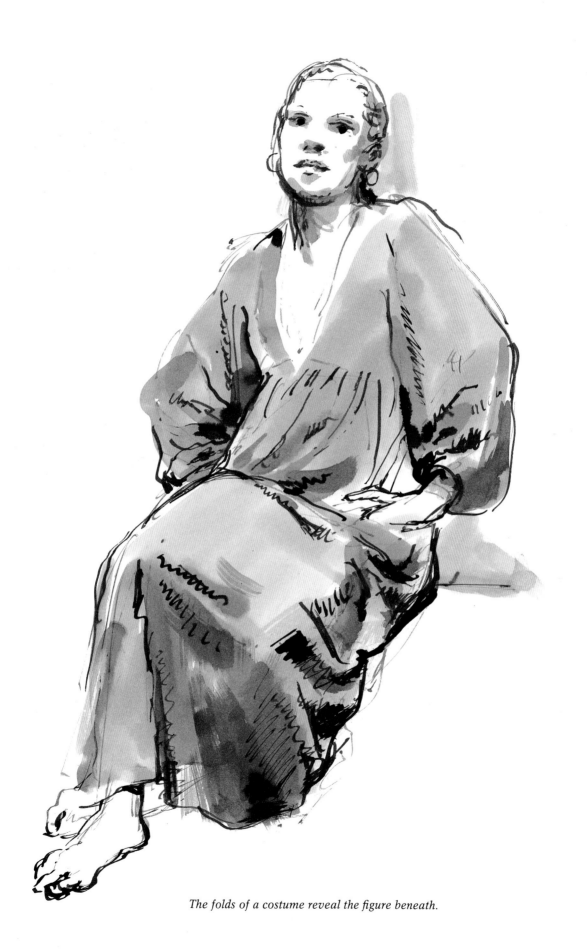

The folds of a costume reveal the figure beneath.

DRAWING ON TINTED PAPER

A useful, relatively easy drawing technique that gives a nice transition from drawing in black on white paper to painting in different colors is drawing on tinted paper with a black, brown, or dark red pencil or Conté crayon and lightening the prominent areas with a white or pink white pencil or crayon. You thus have three de-grees of light and dark (or values, see page 52) with which to estab-lish the volume of your forms in an economical, informative manner. The dark pencil is the dark value, the tinted paper is the middle value, and the light pencil is the light value.

You should model across the form not parallel to the contour.

You can use diagonal strokes or curved ones, as if you were draw-ing a cross section on the figure. Think of a striped mug, which, if tilted in different directions shows a different degree of curve. Make sure the curve of your modeling reinforces the form instead of con-tradict it. You can mix the two techniques, of course.

Curved strokes of white pencil for light areas and dark pencil for dark areas build form on a middle-value, tinted background.

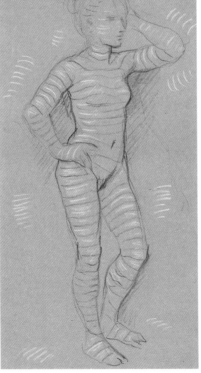

In this exaggerated example, making curved strokes as if the model were wearing a striped leotard is another way of modeling form.

Short diagonal strokes can also be used to reveal form.

Use of light and dark crayon creates volume.

Drawing on Tinted Paper

Once you have understood how to make solid forms by using values, it will be much easier to translate these values into color and still preserve roundness and solidity. Of course, if you want your forms flat and decorative—and there is nothing wrong with that—you would not use the variations of value within the form.

This technique of heightening with white has been used extensively for centuries. Not only is it very helpful for making notes for painting, but whole compositions can be planned out. It is important to be very sparing with the white, or lightest value. It is to be used only for emphasis on important projections. The usual tendency is to overdo it, so that all the middle value is lost, and you end with a white image with dark areas and only the background in middle value. Be careful also not to make the white areas too abrupt lest your figure have flesh with gleaming spots like highly glazed porcelain. The white areas should blend into the form.

Remember that a reflected light in a shadowed area is always much lower in value (less bright) than the light on a prominent form. The area only looks light because it is less dark than the full shadow.

For tinted paper you can use any of the soft neutral shades that come in drawing books or in sheets. Avoid bright, glaring colors. I prefer heavy brown wrapping paper, which comes in rolls at stationer's stores, not art stores, and is amazingly inexpensive. I cut it up to the sizes I want. You may have to check several stores before you find the heavy, nonglossy variety. Occasionally I've discovered drawing pads of similar quality and color. Naturally, if you cut your own sheets, you will need a board or stiff backing when you are drawing.

Too much white on this figure means there is no middle value except the background.

White that remains a sharp highlight on the surface of the form gives a spotty effect.

Reflected light in a shadowed area is much less bright than light on a prominent form (left). The light area of the right example is too strong.

Drawing on Tinted Paper

An alternative to using brown paper is to tint your own white paper by rubbing it first with a soft pastel and crayon and then with cloth. Or you can rub on loose powdered color, called Fresco colors, obtainable from household paint stores. To obtain light areas on such paper, you erase with a rubber eraser rather than adding in white pencil.

I used this technique for the drawing of sunbathers in the painting *Four* (see page 142). I rubbed white paper with red-brown pastel and smudged it off with a rag. I then drew with a red-brown Othello pastel pencil and produced light areas with an eraser. In the sketch of the seated male model, I again used the same method but I added white pastel to emphasize further some of the most prominent areas.

It's great fun making your own tinted paper, since you create your own desired depth of hue with harmonies and variations on the paper before you even start drawing. This was true of the back view sketch of a girl with long hair. I made wild swatches of different-colored pastel at random—using the side of the crayon to obtain wide sweeps of color—and I did not smudge the colors together as in the previous examples. Then I drew on top of my rainbow with brown pastel, rubbed off light areas, and added some white pastel for emphasis. Although the figure is in different colors, the form, I hope, looks solid, thanks to the value modeling.

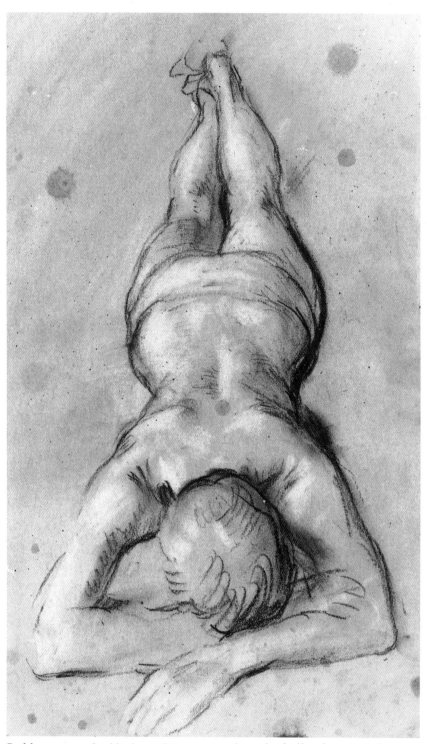

Red-brown pastel rubbed on white paper and smudged off makes a tinted ground. Darks are created with an Othello pencil. White areas are achieved with an eraser.

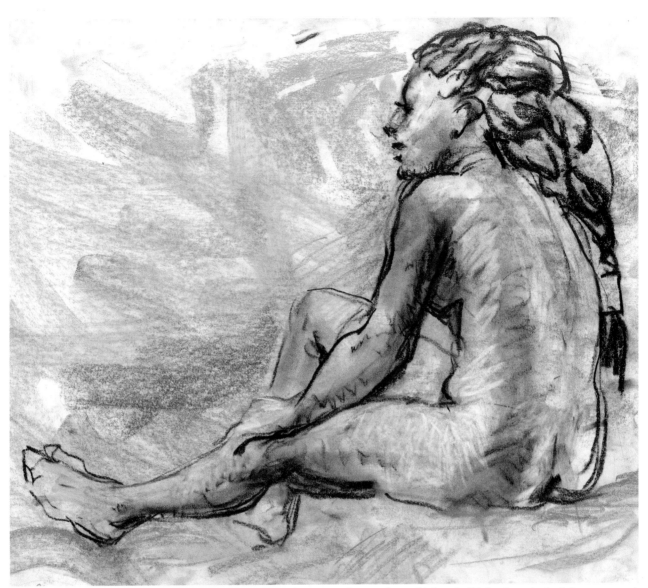

Swatches of different-colored pastel on white paper make a varied ground on which to build the form in dark-brown pastel with touches of white.

PART 2

THE ESSENTIALS OF PAINTING

Before you start to paint, you'll need some essentials for your art. They include basic materials, a grasp of fundamental techniques, and an understanding of the principles of value, color, and composition. Without this equipment, you may have to struggle so hard that you could lose sight of what you want to say in your painting.

Keep in mind that you will nearly always have problems, even in an easy painting, but if you can identify what is wrong, you are on the way to a solution. Problems should be accepted, if not exactly welcomed, as they keep you alert and critical and you learn something from each difficulty solved.

POMONA, 1979, 48" × 36" (121.9 × 91.4 cm).

MATERIALS

The basic materials you need for oil painting are paints, medium, turpentine, brushes, a palette and palette knife, a support, plus plenty of absorbent paint rags. A thorough knowledge of the potential of these working materials gives you the freedom to concentrate on what you are really interested in—painting. If you don't have enough brushes, or the right ones, for what you want to do, or if you are out of medium, you will find yourself floundering, feeling thoroughly frustrated!

Although the initial outlay for materials can be fairly costly, if you look after them, cleaning your palette and brushes after each day's work, they will last a lifetime. In effect, brushes are an extension of your hands, and you do wash your hands regularly! So take care of your inanimate helpers and they will reward you.

PAINTS

Oil paints come in student grade and artist grade. The student grade contains a large amount of filler to pigment, with the result that the colors do not last and are generally duller. I strongly advise getting the best quality, always.

When you select your basic colors, bear in mind that the same color produced by different manufacturers will often be different. I have three raw umbers from three different makers and they all have differences, though all are a cool brown.

The following is my suggested starting list. I've used strong, bright colors because they can always be toned down, whereas you cannot make a dull color look bright.
One very large tube of titanium or
 flake white
cadmium yellow medium
cadmium scarlet
cadmium orange
yellow ochre

Venetian red or Indian red
alizarin crimson
raw umber
burnt umber
burnt sienna
ultramarine
phthalo blue
phthalo green
black

The cadmiums are horribly expensive, but the earth colors (the umbers and ochre) are relatively cheap. You will be using white in every painting, so you'll need more of that paint than any other.

Don't use zinc white as it has poor covering quality.

BRUSHES

The standard artist's brushes are rounds, filberts, flats, brights, and pointed sables. The first four have stiff bristles and are for broad lines or areas. Rounds, which taper to a blunt point, are good for "drawing" wide or narrow linear forms depending on the size of the brush. Filberts, which do not taper, are all-purpose brushes. Flats, which have flat ends, are all-purpose brushes especially for painting large areas, depending on the size of the brush. Brights, having shorter bristles than flats, cover smaller areas and give a more stippled effect.

A good sable brush, used in watercolor painting, has soft hairs that come to a fine point, making it excellent for "drawing" sharp lines in oil paint. I prefer short-handled sables because they give better control. Good sable brushes are very expensive, so look after them.

In addition to these five types of brushes, I strongly recommend a selection of housepainter's brushes. Buy the standard white bristle (not synthetic) ones as plump as possible, from ½ inch to 2 inches wide. They look just like flat artist's brushes except that they have short handles—and they're much cheaper! I find them invaluable.

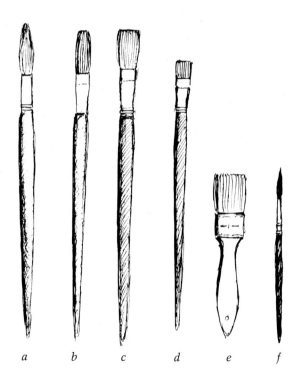

a b c d e f

The standard artist's brushes are rounds (a), filberts (b), flats (c), brights (d), and pointed watercolor sables (f). Broad housepainter's brushes are also useful (e).

They're great for scumbling on paint and for dabbing a glazed surface to remove any streaks and shine. Counting up my collection, I find I have thirty-seven!

Add one interesting-looking new type of brush to your collection every time you go to an art store, and see what it can do for you.

PALETTE AND PALETTE KNIFE

Your palette should be as large as possible. Don't use paper palettes; they're unsatisfactory to mix paints on because paper tends to buckle. My own palette is made of wood and is shaped so that I can rest it on my arm. You'll need two dippers, or small metal cans, attached to your palette. One is for turpentine, for rinsing your brushes as you change from one color to another. (You then dry the brushes by rubbing them on the paint rag, so that you can pick up another

color without smearing.) The other dipper is for medium.

You'll need a palette knife with a blunt end (not a painting knife with a pointed end) for mixing paints and cleaning off your palette when you're through working. Always test it for springiness in the shop before you buy it. If it is not flexible, it will be difficult to mix the paint.

I don't like mixing colors with a brush because it causes the paint to smear instead of leaving it in a little heap. With the palette knife, you can scrape the colors together and squidge them around, adding this and that color, until you achieve the desired effect. By mixing your colors this way, you can set out your key colors beforehand and *then* go from one to another with your brush as you paint. I've found this method avoids the muddy look that is often caused by the wrong color accidently getting mixed into your intended color mixture.

This method of mixing your key colors ahead of time may slow you down a little before each painting session, but it will save you time and frustration later on when you're actually working. You'll have your own unique color scheme all prepared instead of having to fiddle around with each stroke.

MEDIUM

Why do you need a medium? Without a medium your colors will lose their vitality and "sink" or fade when they dry. Although pale colors don't change much, bright and particularly dark colors will go dead. They will dry very differently from the way they look going on, but if you rub a little medium over a dry color, you'll suddenly see it the way you painted it.

Medium is also important because it lubricates the paint; without medium you'd have to scumble your paint on with a dry brush or use a deadening thinner like turpentine. Medium also makes the paint adhere to the canvas better and helps to preserve and hold the colors. A warning: only use a little! Too much medium produces heavy, oily smear that will be unpleasant to paint over and could cause problems later on.

Your medium can be just linseed oil, or you can make a much better medium yourself (as I do) by mixing the following three ingredients in a screwtop jar: one part damar varnish (dries fast), one part stand oil (dries very slowly), and six to seven parts turpentine (thins the mixture). Then shake vigorously.

Depending on how fluid you want your paint, you'll need only about two tablespoons of medium for each painting session. However, when you want a glaze, you'll need proportionately more medium.

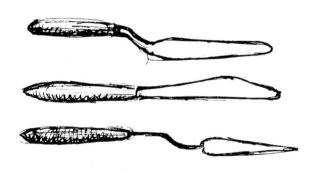

Palette knives have blunt ends for mixing (top and center). A painting knife has a thin metal neck and a pointed end for applying paint to canvas (bottom).

Always test your palette knife for springiness in the shop. If the knife is not flexible, it will be difficult to mix the paint.

Materials

SUPPORTS

Stretched primed canvas makes a good painting support. A stretched canvas is mounted on interchangeable wooden strips called stretchers. Stretching your own canvas is relatively easy. I do my own, making the painting surface larger than I think necessary to allow the painting to grow. First, I lay the canvas over the stretchers with carpet tacks, hammering them in only halfway so that I can get them out easily. I use the staple gun only when I have decided on the final size of the canvas. I always stretch my canvases as tight as possible because I like a drum-taut response to my brush. Little wedges for inserting in the corners are supplied free with the stretchers at art supply stores; there are eight to a rectangle, two at each corner for expanding the frame and tightening the canvas.

Since raw canvas deadens color and eventually rots when covered by oil paint, I recommend a primer coat of acrylic polymer gesso. Because I like a very smooth surface, I often use three coats of primer. Applying them isn't really very time consuming, though, because the acrylic paint dries very quickly. Of course, the final choice of surface is up to you. I advise against a coarse weave, however, because the texture could call attention to itself.

I caution you not to use canvas boards! Although convenient, I think they make paintings look awful. When students of mine have ignored this admonition, they were always sorry and felt they had ruined what might have been a successful painting.

If you want a rigid surface, paint on panel board, or Masonite, at least ⅛ inch thick (the thicker the better). Use the smooth side only. The rough side has far too emphatic a mechanical surface to be suitable for painting. To make the primer coats of acrylic gesso hold properly, you'll need to sandpaper off its glossy surface a bit. To prevent the board from warping, it's advisable to prime both sides of the panel.

Keep in mind that the size of your painting will ultimately determine the panel's thickness. Since Masonite is extremely heavy, for years I painted on panel and loved its resistance to my brush. But when it became too difficult to move the large paintings, I switched—with considerable difficulty—to canvas. I even tried gluing my canvas to the board and took the painting off afterward, but I still had the weight problem while working. I also had a possible cracking problem when I pulled the canvas off the panel.

POSITIONING YOURSELF TO PAINT

You will find it a lot easier to apply paint correctly if you and your canvas are in the proper positions. Do not place the canvas flat on a table or you will run the risk of a built-in false perspective, as I discussed in the section on drawing. Instead, use an easel at eye level when you are standing. It is much better to stand than to sit because you can move around easily to view your painting from different positions. If you sit, you will tend to stay put.

The canvas need not be vertical on the easel but sloped at a slight angle. If the painting is large, you will have to lower the easel support in order to work on the top of the canvas comfortably, since it is always tiring to raise your arm above the horizontal. Similarly, you'll have to raise the support in order to work on the bottom of the canvas, because arm movements are less secure in a sloping position.

Don't stand too close to the canvas but about two feet away. Paint with your arm extended, though not rigid. Don't hold your brush too close to the ferule but about one half to two thirds down the handle. Don't rest your hand on the painting except for the most precise details. For those you can (1) extend your little finger as a support; (2) put a piece of clean paper over the area on which you want to lay your hand, lightly holding it in place with tape if it doesn't stick to the tacky paint; or (3) use a mahl stick or any long, thin, stiff support. A mahl stick, obtainable from art stores, is a long sectional metal rod with a rubber tip to rest on the edge of the stretcher. You hold it away from the painting with your left hand, and use it as a bar on which to support your right hand. (Unless, of course, you are left-handed, then you would reverse the process.)

Of course, you can't hold your palette at the same time, so have your worktable close by, with the palette on it; then you can reach over to pick up more paint on your brush without having to put everything down.

Have a mirror handy, at least a 5 × 7-inch hand mirror, for looking at your painting in reverse. Better still, have two mirrors. The second should be hung on the wall behind you. You thus check your painting by standing well away from it and looking at the painting in the mirror. You'll get a lot of surprises and advice from that mirror image! It will give you completely new eyes with which to see your work.

I spend half my time painting just walking away from the canvas and back to it, looking at it in the mirror, turning the picture upside down to get a fresh vision.

Finally, be comfortable! Wear a coverall and don't mind getting dirty! You can't paint freely if you are worrying about spoiling the rug or your new sweater.

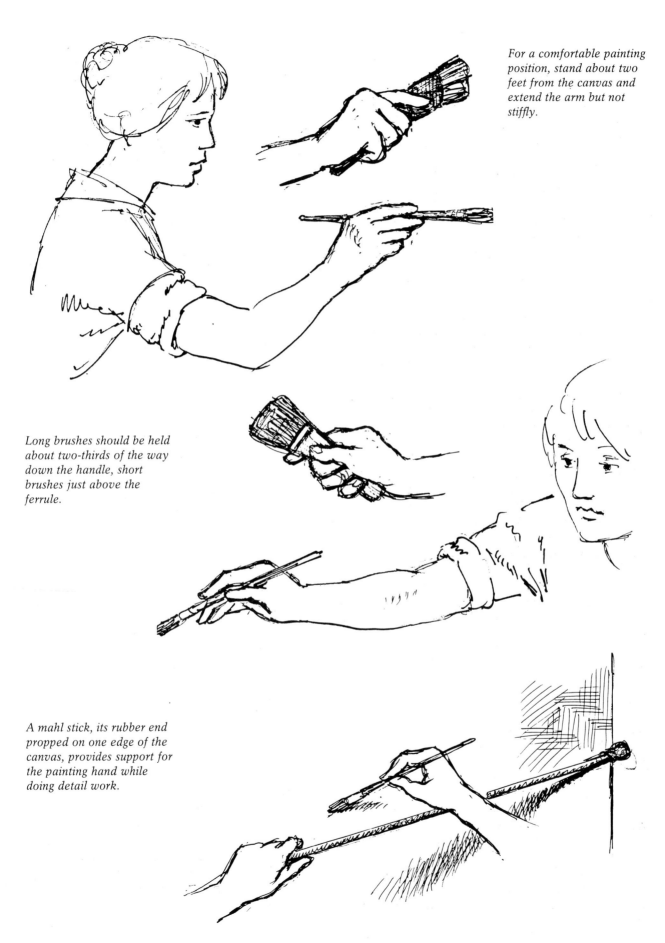

For a comfortable painting position, stand about two feet from the canvas and extend the arm but not stiffly.

Long brushes should be held about two-thirds of the way down the handle, short brushes just above the ferrule.

A mahl stick, its rubber end propped on one edge of the canvas, provides support for the painting hand while doing detail work.

BASIC WAYS TO APPLY PAINT

A practical knowledge of how to put paint on a surface directly influences the visual impact of the painting and ultimately its aesthetic appeal. In effect, you are making a statement about your subject by the way you have handled the physical application of the paint. For example, a scumbling technique can give a dry or crumbled surface, while glazing gives a rich and translucent surface. The point is that techniques themselves say different things or convey different ideas in paint. But it is important that you know how to apply these techniques correctly.

I once had a student who squeezed paint from the tube onto her brush like toothpaste! Now, that's *not* the way to paint, so I'd like to introduce you to four ways of applying oil paint that can give you four very different effects, even using the same colors. The first three require a brush. The fourth makes use of a palette knife.

DIRECT PAINTING

The most common method of applying paint is direct painting. You pick up some paint on your brush, using very little medium, and place a stroke on the canvas or board. Of course, the stroke will look different depending on the kind of brush and the thickness of the paint.

SCUMBLING

In scumbling you use a dry brush, with no medium. Then pick up the paint with the brush and get rid of the surplus paint by rubbing it on your palette or on a paint rag, and cover a dry, painted surface with a hazy, powdery looking veil that lets the underlying color show through. The surface *must* be dry; if it is not, you are not scumbling at all but direct painting on a lubricated surface.

GLAZING

I've been struggling with glazing ever since I started painting. Essentially, glazing is covering a dry, solidly painted surface with a transparent layer of another color—a layer of colored glass, as it were—that allows the underlying image to show through.

To mix a glaze, combine a puddle of medium and a little bit of paint on your palette. Then, with a big brush cover the area you want glazed. The result can be either a

Yellow ochre is directly painted over green.

A glaze of sap green is applied to a figure painting.

subtle or a strong change of color. You can also obtain an intense brilliance, with a richness and depth that can't be achieved in any other way. But be aware that if a glaze is not handled properly, it can look like a badly done, streaky watercolor wash, which will weaken the forms in your painting and give the surface an unsightly shine or an unbalanced brightness.

After much experimenting, I think I have found some solutions to using this fascinating but somewhat difficult technique. For a suc-

Yellow ochre is scumbled over green.

a b

c d

Blue and brown glazes are undabbed (a and c) and dabbed (b and d).

cessful glaze, first you must have a heavily painted surface that is thoroughly dry. Second, as soon as you have applied the glaze, you need to start dabbing it off with a large, dry brush. It's a good idea to change to another dry brush when the first one gets too wet from glazing mixture. This dabbing motion wipes away the streaky quality, removes shine, and softens edges. It also adds a very faint texture to the surface and helps it to dry. Third, as soon as the glaze is tacky (if you can wait until then,

I can't always!), add a new coat of paint to some of the modeled areas to bring out the form that has been recessed and flattened by the glaze.

The new direct paint can be dabbed on too, if you don't want the brush to slip around. Start with the lightest parts in the painting with your direct paint and work into the glaze, ending perhaps with a dry brush.

While the glaze is still damp, you can repaint in new, modified colors. When the glaze is dry, you can scumble on top, of course. You can

go on like this as long as you like, providing you follow the sequence: (1) direct paint, then dry; (2) glaze, then dab; (3) repaint.

Be careful not to put a new color glaze over what you think is a dry glaze without direct painting in between. You will either pull off the old glaze, creating awful muddy streaking, or turn the area into a transparent mudbath, or both. Between the application of the first glaze and the second, you *must* have some direct painting.

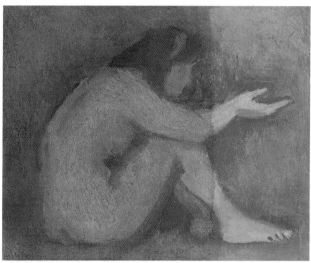

The left side has a raw umber glaze over heavy underpainting; the far right side is unglazed. The glaze makes the form look flat.

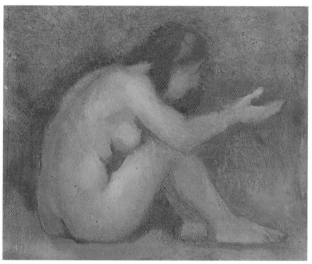

New light-colored modeling in direct painting over the glaze emphasizes the form again.

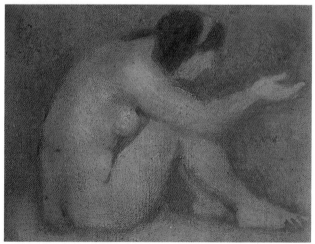

A second glaze, of alizarin crimson and Auroline, makes the form look less flat than under the first glaze because of the subsequent modeling.

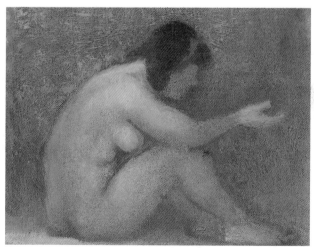

Modeling is again intensified by direct painting in lighter values on top of the second glaze. The rather warm color is cooled down, and scumble is added to the top left background.

Basic Ways to Apply Paint

Below is monochrome version of a painting called *The Adept* that you will see completed on page 135. I've included it here to show you how you can completely change the colors in a painting by superimposing a glaze. Ask yourself which of these stripes of glaze looks best? Obviously, this is a personal aesthetic decision the artist has to make in relation to the feeling and mood of the painting. In this case, I thought that for this particular subject, an astrologer, perhaps the red was too earthy and emotional and the green too obviously suggested the occult. Therefore, a glowing yellow (for the sun) or blue (for night and stars) might be my choice. But most important, there is intrinsically no right or wrong; it is a creative decision.

One further note: A glaze can be very useful when you have too many colors in a painting and the glaze acts as a unifying filter.

In The Adept, *stripes of alizarin crimson glaze (left), auroline glaze (center), and thalo green glaze (right) completely change the underlying color. Note that the stripe of color directly below the picture is undabbed. The stripe at bottom shows the dabbed glaze colors.*

IMPASTO EFFECTS

One method of applying paint, the impasto technique, dispenses with brushes altogether; you apply paint to the surface directly with a palette knife or a painting knife. The result is a very dramatic, emphatic expressionist effect, especially, I've found, in figure painting. The method is also very useful for texturing elements such as sidewalks or walls. In *Ruined City*, painted after a visit to Morocco, I used the impasto technique throughout. I built up the surface with a palette knife to convey the effect of rough, crumbly stone and broken, peeling plaster. To further emphasize this texture, I glazed the surface when it was dry and then blotted it off, leaving a residue of paint in the recessed areas. I repeated the process many times, adding more solid paint "plastering" on top. Since thick paint dries slowly and I wanted each layer of paint intact, I mixed MG quick-drying white (made by Grumbacher) with my color but without medium.

Using a palette knife, I plastered paint heavily over previously painted, glazed, and scraped areas to enrich the texture.

In Ruined City, *impasto is used to give the rough-textured effect of ancient, crumbling stone and plaster.*

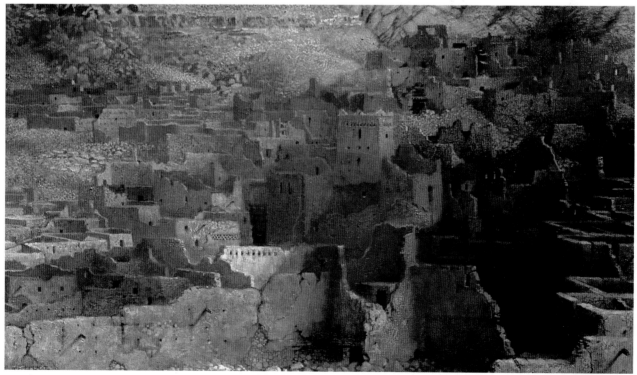

RUINED CITY, 1983, 72" × 35" (182.8 × 88.9 cm).

VALUE

You are using two scales of effect in painting, value and color. *There is no one correct formula for their use.* You, as the artist, must find a solution that is right for your particular painting.

Value (I prefer the word *tone* because "value" is associated in my mind with market worth) is defined as the relative lightness or darkness of a color. What really matters is seeing the value relationship between colors. For example, a yellow ochre acts as a light value on a purple ground but as a medium-dark value on a white ground.

CREATING SOLID FORM THROUGH VALUE

The effect of solid, three-dimensional forms is created by using correct values. If you place two different colors that are the same value side by side, you will get a sort of dazzle effect, which remains flat because the values are the same. Thus an object painted in one value, even if many different colors are used, appears two-dimensional. So if you want a flattened, stylized image, don't employ many value contrasts.

Generally white and light values come forward, and black and dark values recede. Therefore, if you want maximum modeling, to give a three-dimensional effect, use emphatic value contrasts. A very dark value against a light value will catch the eye, but it may seem to jump off the surface or bore a hole through it. A gradual shading from one value to another creates the effect of a three-dimensional form on the surface of the painting. Notice, however, that both very dark and very light values will seem to be in front of medium values. The correct variation of values will convey a sense of rounded forms, but incorrect values destroy that sense.

A judicious use of contrast will emphasize the area of painting you want noticed and heighten its drama. Imagine spotlights illuminating the principal characters in a tableau. These light areas linked together by your eye make a pattern. The strong chiaroscuro (light and dark) values in the work of Rembrandt and Caravaggio give it a dramatic effect. Unified, closely related values are characteristic of Van Eyck's and Seurat's relatively calmer figure paintings.

When you light a figure or object from underneath, you create an interesting effect that can be interpreted as ethereal, luminous, or sinister. Horror movies make use of this kind of lighting. But Georges de La Tour used this same lighting technique to create beautiful and tender paintings.

The value of a color is affected by its background. Yellow ochre looks light against purple (left) but medium dark against white (right).

With one value, the object looks flat, like a coin or disk.

Light values tend to come forward, giving a convex effect (left). Dark values tend to recede, giving a concave effect (right).

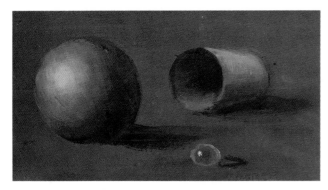

The ball and the container have volume because multiple values are used to make the forms advance and recede in space. The drop of water in the foreground is solid yet transparent. Light passes through it, forming a light value where a dark one would be if the drop were opaque.

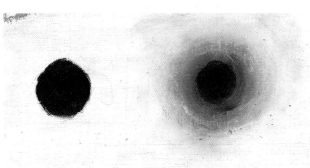

Strong contrast jumps out at you and catches the eye (left) but does not give the sense of recession that is created by a gradual shading from one extreme to the other (right).

The black-and-white shapes appear to be equally in front of the three greens, which have different colors but similar values.

A correct placement and graduation of values and colors give solidity and roundness to form.

Incorrect use of values and colors gives forms a flat, two-dimensional appearance.

The related, unified values in the portrait on the left emphasize the overall shape of the face. The wide range of values on the face at the right emphasize its contours and give a dramatic effect.

Underlighting heightens the dramatic effect.

Value

In the following four paintings, I worked through several versions of each one until I found the values that best expressed my feelings about the subject.

MIDDAY required a sense of all-pervasive sunshine, so I kept to a closely related scheme of yellows and greens, avoiding any pronounced dark values as disruptive of a glowing summer day. A few white flowers are pronounced high-key values, but they blend into the yellow.

The girl's turquoise dress is different in color from some of the leaf greens but is close to them in value. I wonder now if I should have the color closer as well in order to reduce contrast further. What do you think?

The blue of the girl's hatband shows up clearly because it is the only real blue in the painting, but its value is about the same as the green.

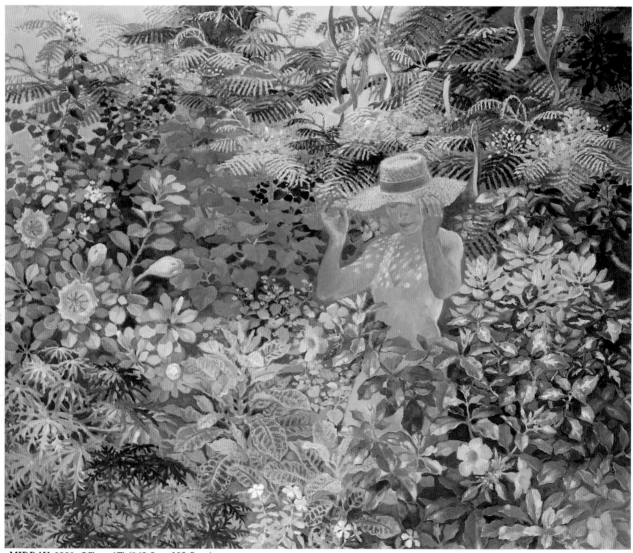

MIDDAY, 1981, 56" × 47" (142.2 × 119.3 cm).

RED GARDEN says heat! Only reds and yellows are used, but I intensified the effect by keeping them closely related in value. Even the white spots dotted around like sparks are linked in value to the neighboring yellow leaves. Thus abrupt contrasts are avoided and the effect is of a simmering fizz. The white flowers at bottom left are the only prominent jump in value.

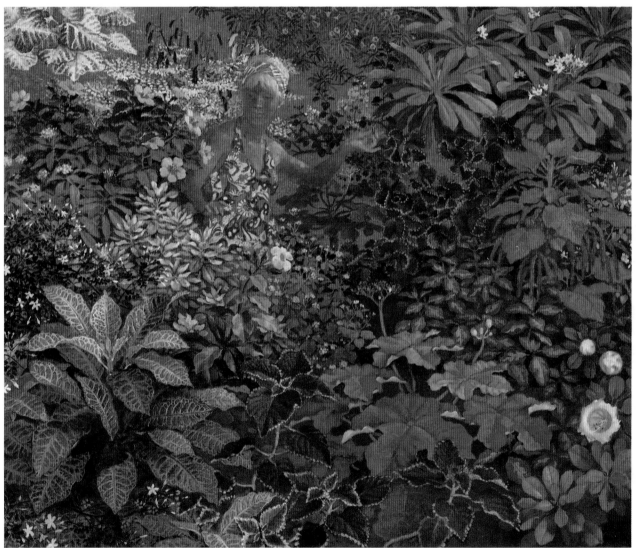

RED GARDEN, 1980, 58″ × 48″ (147.3 × 121.9 cm).

Value

IRT EYE has an even more restricted color range than *Midday* or *Red Garden*, but its value contrast is extreme. It is really a dark painting with two strongly defined light areas—the oblong window of the subway car, behind which the passengers glimmer as if they were under water (they are underground, after all!) in the greenish, fluorescent light; and the watching eye on the outside of the subway car that is similar in color and value.

The orange and green lettering on the bottom is the only variant in color, but it is similar in value to the rest of the painting.

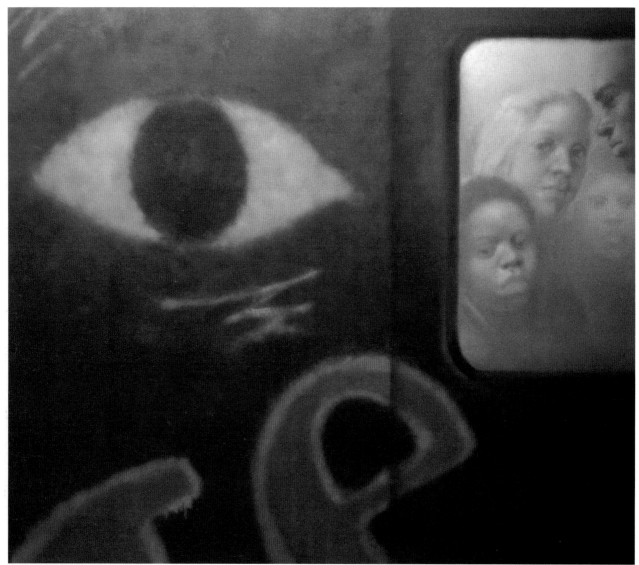

IRT EYE, 1977, 40" × 33" (101.6 × 83.8 cm).

CHATEAU has very little variation in color. The only noticeable color is the reddish curtain at the right. The value contrasts, however, are extreme. One side of the girl's face is almost obliterated by shadow, and one shoulder is silhouetted against the light of the receding doorway. All is in shadow except for the strong illumination on the right half of the face, behind the girl's shoulder, and in the light-filled curtain. The intention here is to convey the slightly ominous feeling that my husband and I had about a vast dark house in Corsica that we had once lived in.

Now suppose I had painted *Château* in bright colors with little value contrast. It would be transformed into a cheerful modern interior. Or if I'd painted the figure in light, bright colors, she would not be enveloped by the house, as she is here, but would appear separate from her environment.

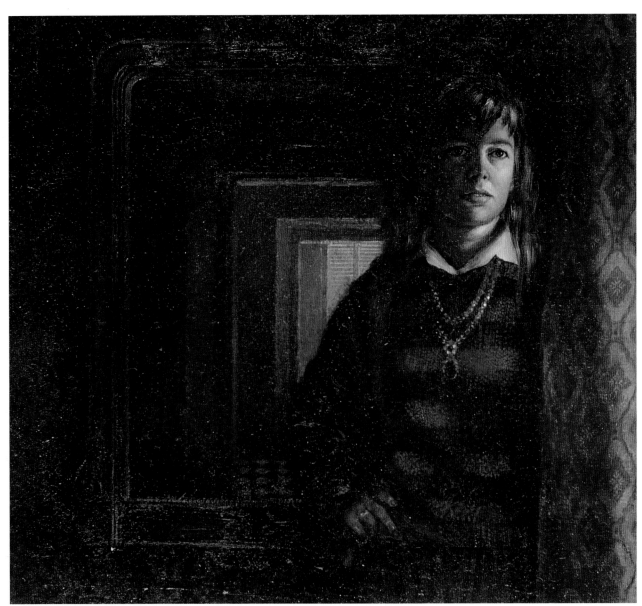

CHATEAU, 1961, 19½" × 19½" (49.5 × 49.5 cm).

COLOR

The choice of color is an aesthetic decision that is completely personal. To me, displeasing color—color perceived as ugly—seems to be much more easily identified and defined. In the following pages I have some suggestions as to how to overcome so-called ugly color. They are based on the repeated appearance of unattractive color and color dilemmas that come up in the work of students and also, alas, in my own work.

If you don't like the color in your painting, there are certain ways of thinking that have helped me to locate the difficulty and that can help you. Here I'm talking about using judgment, not applying a formula from a color chart; painting is, after all, not an application of rules but a creative process of discovery.

DIAGNOSING A PROBLEM

Here are two questions I ask myself when I am having problems with color. *Are there too many colors in the picture?* Does the eye have visual indigestion? This is the most common of all problems.

Young artists generally use too many unrelated colors in their work and then wonder why it looks crude or jumpy or just plain ugly. There is absolutely nothing wrong with using a lot of bright primary colors, but if you don't like the result, ask yourself if you could eliminate one or two colors completely and substitute another version of one of the remaining colors.

For example, a painting can have too many colors and fail to organize them into a composition, as seen in the example at top right. In the example below (bottom right), all the reds and oranges have been eliminated. Directions for the eye have been established by linking colors and values—the pale green and pale yellow.

Is the painting equally divided between two strong opposing colors? Let's say a strong red and a vivid blue seem to be pulling a painting apart. There are several solutions to this problem.

You can turn one or both of the fighting colors into more subdued, muted hues by mixing them with black, white, or other colors.

You can allow one color to dominate over the other so that you have a red painting with touches of blue or a blue painting with touches of red.

You can add a mediator, that is, black, white, or another color, to separate or link the two opposing colors.

You can add three mediators, such as black, white, and yellow, to create shapes and attract interest away from the red and blue.

Or you can subdue both the painting and the mediators by mixing them with black, white, or other colors.

Still another solution is to change the colors of the entire painting by covering with a unifying glaze. An example is on page 50 in the section on glazes.

This painting has too many different colors. They are scattered over the surface without being organized into a pattern.

Here the number of colors has been reduced by eliminating the reds and oranges. The pale green and yellow shapes are linked by similar values and colors, assembling in a pattern.

Here the strong red and blue pull against each other, destroying the unity of the painting.

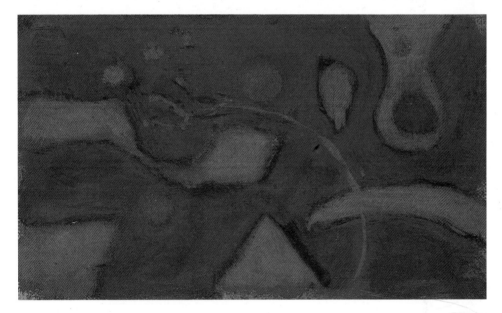

Both the red and blue have been subdued by mixing them with other colors so that they are less strident.

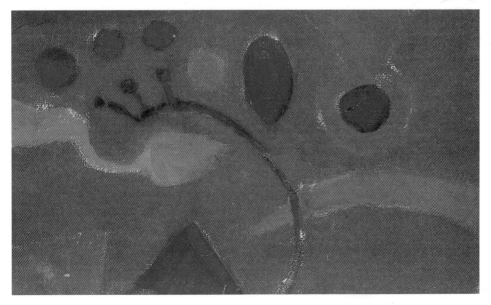

One color (red) dominates, reducing the competition with its opponent (blue).

Color

White is added as a mediator between the blue and the red.

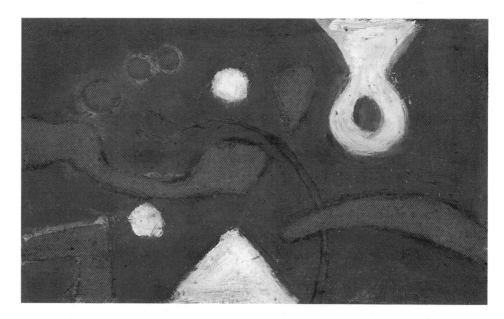

Three mediators—black, white, and yellow—divert interest from the opposing red and blue.

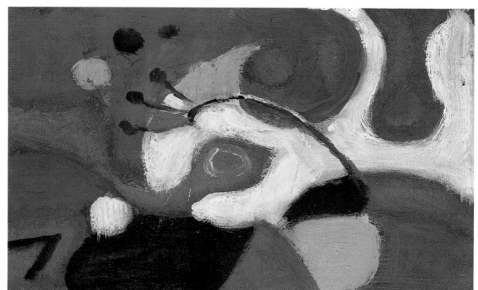

By mixing in other colors, a subdued version was created.

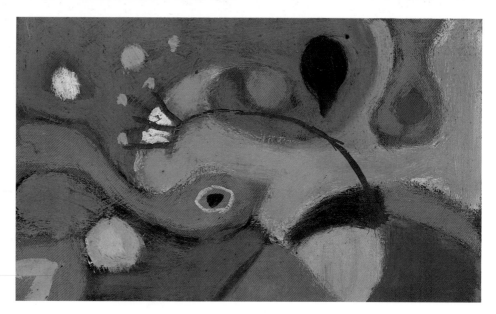

COLOR VARIATIONS

By comparing the following four paintings, you may gain some insight into ways to vary your use of color.

UNDER THE FLAMBOYANT needed mediators to keep two strong opposing colors—bright red and bright green—from breaking it apart in the middle. If you cover the central yellow area and the figure, the painting divides into a red top and a green base. The yellow provides a bright diagonal that links the two dominants.

Now cover the figure again. The yellow is still not strong enough to unify the picture. There is no core to the picture; it still splits in half, though now diagonally. To provide a strong central focus, I used the figure's light-toned blouse and the cool blue near her right arm as color changes to attract the eye. The dots of intense blue on the black skirt make a visual link with the dark, silhouetted bush on the right.

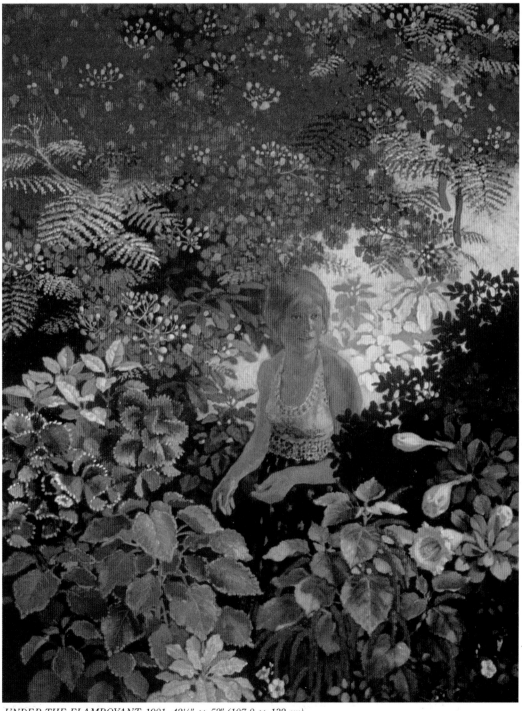

UNDER THE FLAMBOYANT, 1981, 42½" × 52" (107.8 × 132 cm).

Color

FRUIT AND FRIENDS links areas of red and blue on an off-white background with a superimposed design of yellow fruit. The soft-edged red background that defines both the right and left lower edges is extended by the dots of scattered peppers and the halved tomato into the blue areas. The dark shapes of the eggplants, olives, and seeds strewn throughout the composition provide the staccato element in the design.

FRUIT AND FRIENDS, 1978, 48″ × 31″ (121.9 × 78.7 cm).

Color

MEPHISTO'S S could have produced visual indigestion from two equally demanding colors if I'd used a lot of blue. As it is, the red dominates, and I see it as a red painting. The four yellow circles act as mediators. The painting is seasoned with blue, weighted with black, and accented with white.

The title of this painting refers to Mephisto's kingdom, or hell, traditionally thought of as fiery. The passengers in the subway car are his imprisoned subjects. You can trace the blue outline of the S as it crosses the yellow windows, passes through the word fuse, and re-emerges as an arrow-barbed tail in red and blue on the left side.

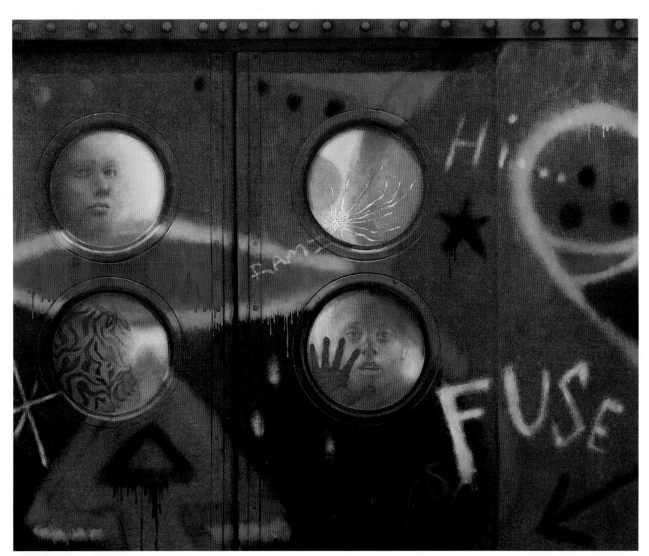

MEPHISTO'S S, 1976, 44" × 36" (117.7 × 91.4 cm).

LIBRA is a good example of the difference between color and value, specifically of the principle that even the lightest colors look dark against white. Notice that the yellow of the window appears quite dark in value against the white background.

In the black-and-white photograph of this same painting, both the yellow and the red, which have the same value, appear very light gray. Notice how weak the top circle looks without the intensity of color and how overpowered by the bottom dark circle.

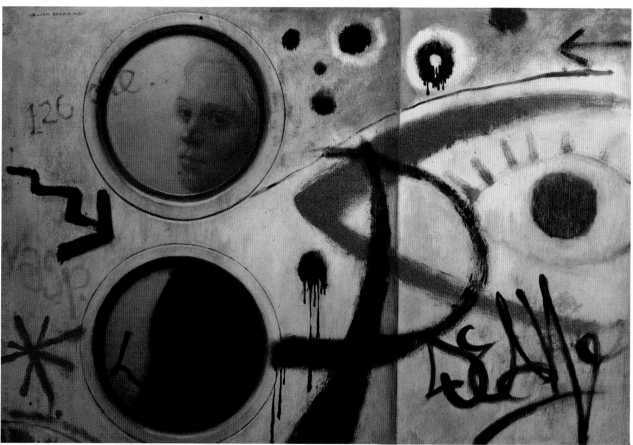

LIBRA, 1978, 38" × 26" (96.5 × 66 cm).

A black-and-white version of Libra *reveals the similarity of the yellow and red in value and the weakness of the top circle when it has no color to give it emphasis.*

COMPOSITION

To my mind, composition is an absolutely essential component of a painting. It is creating order out of the indiscriminate flux around us, an activity that requires artistic judgment. It is characteristic of living things to make order, and it is characteristically human to want to see beauty in that order.

TAKING THE EYE ON A TOUR

The word *composition* often throws people into consternation and alarm because they think it is something very difficult and obscure. It is nothing of the sort. Composition is just a way of taking the eye on a tour through a painting and pointing out things to notice along the way. The eye should be guided, not forced, but if it has no guidance, it will flounder in a mass of contradictions and distractions.

It is the degree of emphasis created by such things as the size, color, lighting, and direction of forms that guides, or directs, the eye. A successful composition has main themes or patterns, which the eye sees first, and secondary ones, which the eye sees later. Both patterns stimulate and resolve arrangements for the eye. A poor composition is a jumble of conflicting directional signals in which the eye is mired and doesn't know where to go. Each painting must have its own composition, depending on what you want to say about the subject.

Don't think of the diagrams in the following examples in any way as models to copy. They are just diagrams to help clarify the idea of composition. And keep in mind that a simple composition can be as successful as a complex one.

Let's take an undulating path that crosses a brook as suggested in the accompanying example. The elements of the composition are two diagonals, one serpentine and the other relatively straight. We come to a wood, represented by a large green mass with vertical emphasis. Beyond the wood is a lake, represented by a basically horizontal blue area. Now a white shape appears, perhaps a bird. A dark spot, perhaps a person, provides a focal point in the foreground. The very light spot and the very dark spot have immediately attracted our attention.

Here we have a very simple abstract design that can be elaborated on ad infinitum to cause your eye to see some things first and others second. The degree of emphasis directs the eye.

If we didn't want to see the figure, it could be a pale blue and become almost invisible. If the wood became a much darker green not only would it so dominate the

A wavy, diagonal ochre line intersecting a straight blue diagonal suggests a path crossing a brook.

A vertical green area suggests a wood in front of a horizontal blue area that might be a lake.

painting that you wouldn't notice anything else, but its shape would get mixed up with the dark blue pond. If the pond was made a very light blue, it would almost disappear into the pale green so that the horizontal stabilizer would be lost.

Note the relative prominence of each shape in the example at the bottom of this page. Although you might expect the white comet shape to come forward, it remains behind the black dots because they are in such strong contrast to the rest of the painting that they catch your eye first. Also your eye makes connections between the dots so that they appear to form a continuous line.

The blue snakelike form, the blue crescent moon, and the green spot, all low in value, are almost invisible. The red dot, although it is almost the same value as the background, is highly visible because it is a contrasting color.

The white spot, which is in strong value contrast against the dark sky, attracts your attention much more than the moon. If I had put the spot nearer to the head of the comet, your eye would immediately link it to the comet.

A white spot against the blue might be a bird. A dark spot that might be a person focuses attention on the foreground.

The line of black dots, the red dot, and the white dot stand out because they contrast in value and hue from the other shapes and the gray-green background.

Composition

CREATING MOVEMENT THROUGH COMPOSITION

Composition greatly affects direction or movement in a painting.

An emphasis on horizontals in a composition tends to convey a feeling of calm and stability, possibly because of their association with landscapes and seascapes. When angular shapes are superimposed and some of the horizontals are eliminated, the whole atmosphere changes and becomes more energetic. In the example at right (middle), the viewer's eye links the three black pyramids with the eye shape to form a vertical line up the center of the painting. The bottom half of the sun circle, although it is pure white, is almost invisible against the light lemon color and so does not distract the eye from the vertical thrust.

After eliminating all horizontals and verticals by blocking in the background and filling in the forms, a new diagonal thrust from lower right to upper left is emphasized in the example at right (bottom). The viewer's eye connects the pointed red shapes shooting across the painting. The pyramids cease to form a vertical, their line being broken by value and color. Because of its strong contrast with the background, the small white spot on the left attracts your attention almost as much as the powerful reds. The blue triangle at the right remains relatively unimportant in spite of its size because the mid-blue tends to fade into the purple, equalizing value and color.

Horizontal shapes tend to suggest the calm of scenes of land or sea.

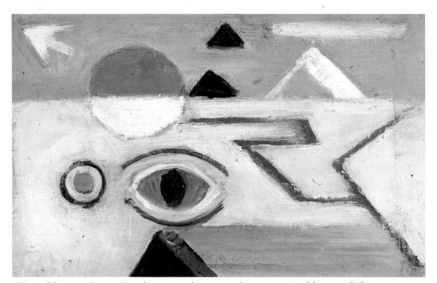

The addition of angular shapes to form an almost vertical line and the elimination of some horizontals create a more forceful effect.

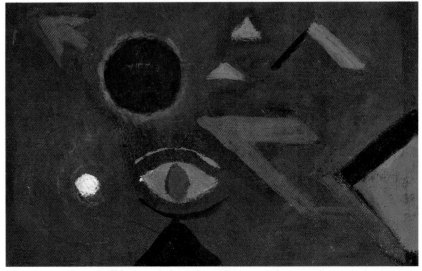

The elimination of all horizontals and verticals and the introduction of a line of pointed red shapes emphasize a diagonal thrust.

Diagonals imply energy and thrust, as in the running figures in the example below (top). Contrast them with the vertical walking figures in the example at the bottom of the page, which suggest a sense of calm.

Such generalizations are really only of use when analyzing what seems wrong with the feeling of a painting. If, for instance, you want an energetic painting of people rushing around, but the finished work looks set and static, you might ask yourself if there are too many verticals and horizontals in the composition. If, however, you want a tranquil feeling, but some- how everything looks agonized and unsettled, perhaps there are too many diagonals and sharp angles attacking the eye. Perhaps you'll need to eliminate some of them and emphasize the verticals and horizontals.

Diagonal lines formed by the running figures suggest energetic action.

Strolling vertical figures seem calm.

Composition

CREATING MOOD THROUGH COMPOSITION

The way that various elements of a painting are combined within the format of the chosen surface can dramatically affect the painting's mood. Although each painting must be seen as a unique situation, there are some generalizations about the arrangement of elements that you might consider.

Vertical elements in a vertical format stress height, such as soaring tree trunks. Straight lines and sharp angles give an austere feeling (think of winter trees). Vertical elements in a horizontal format tend to emphasize mass, such as a thick cluster of trees.

Horizontals in a horizontal format suggest calm and distance. Repetitive shapes such as clouds and an undulating horizon line lend coherence. Curves suggest opulence and luxuriousness.

The relation of the size of the figures to the amount of space around them also affects mood. The figures of mother and child in the example on the opposite page (top) are necessarily prominent because they fill most of the space. The figures in the example on the opposite page (bottom) suggest a mood of loneliness because they are much smaller in relation to the surrounding space.

Vertical shapes on a vertical surface convey an impression of height.

Vertical shapes on a horizontal surface suggest mass.

Horizontal shapes on a horizontal surface give a feeling of calm.

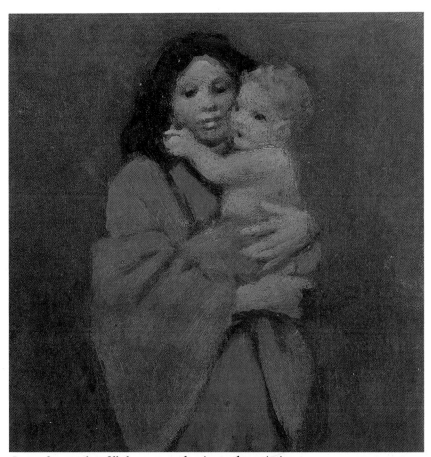

Large figures that fill the canvas dominate the painting.

Figures surrounded by a large area of space may seem lonely.

Composition

Most, if not all, powerful religious symbols and archetypes have a compelling compositional structure. The British art historian Sir Kenneth Clark has noted how the iconic power of the image of Christ crucified is visually reinforced by the abstract geometric form of the cross on which he hangs. The Chinese symbol of yin and yang (a circle divided by an S line) and the Buddhist mandala (basically a circle containing a square or divided into four sections) are also good examples of symbolic forms.

These symbols can provide both structure and meaning to a painting. For example, I did a series of paintings of women under transparent plastic umbrellas, in which the umbrella, seen from above, forms a circle. Although I didn't plan anything symbolic, it seemed so right that several paintings sprang from this visual image. Only later did I realize that I was painting magic circles—mandalas—which perhaps suggested a closed world, a womb, a protection, or something essentially female.

HALF AND HALF, 1971, 43″ × 29½″ (109.2 × 74.8 cm).

In this painting, the umbrella came to symbolize a closed, protected place from which to view the world.

I did one deliberately symbolic painting called *Closeup*, using two magic circles of a hinged mirror, normal and magnifying, to show two versions of a face. In the upper circle against the sky and above the water the face was happy, but in the bottom circle, underwater, the smile had become a howl of anguish. This device suggested the Jungian image of the psyche, in which the conscious self may appear cheerful but in the subterranean depths of the unconscious the person utters a cry of pain.

In general, I'm not too fond of deliberate and obvious symbolism. I prefer suggestions, of which I'm often unaware until I've finished the painting. I feel something is right in my dialogue with the painting I'm working on if I can follow its faint, inaudible signal. That is the reason I suggest you look at your painting in mirrors, upside down, and from a distance, so that you can pick up the suggestions that the painting will make to you. These different ways of looking at a painting give you new eyes with which to discover hitherto concealed compositional directions and suggestions.

In Closeup, *the smiling face in the upper circle and the anguished face in the lower circle reflect the Jungian division of the mind into the conscious and the subconscious regions.*

CLOSEUP, 1970, 19″ × 19″ (48.2 × 48.2 cm).

PART 3

WORKING OUT AN IDEA

A painting has a life of its own. It begins as an idea in the mind of the painter and is gradually worked out from a tentative image to full maturity. As it develops, it gives suggestions back to you, the artist, if you sit quietly and contemplate it. In this part of the book we'll work out an idea together. We'll put down an initial image, respond to that image, and if necessary, make changes and changes and still more changes. In short, we shall have an adventure.

This procedure can be followed for any painting, but to establish limits for this particular painting adventure, let us make a portrait of a young woman with lots of dark hair.

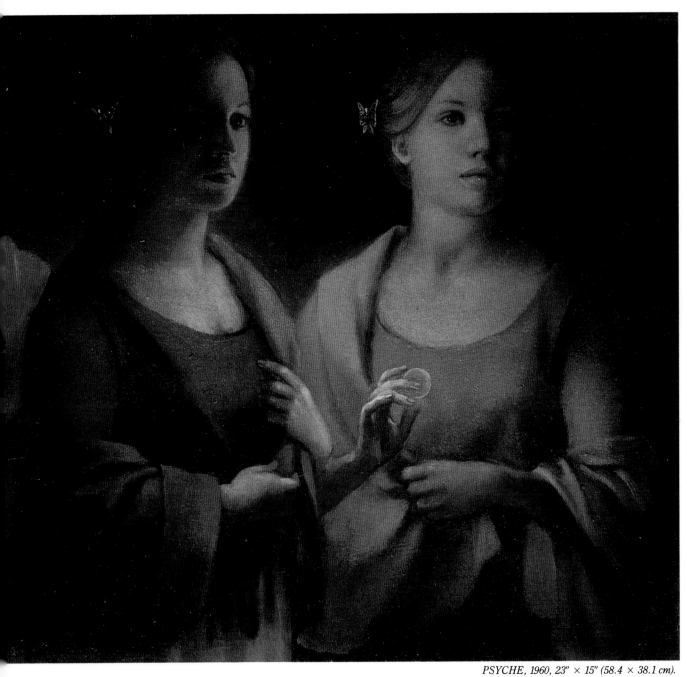

PSYCHE, 1960, 23" × 15" (58.4 × 38.1 cm).

PRELIMINARY DECISIONS

Before starting to paint, we'll make some preliminary decisions about composition and color. Then we'll go through the process of making a painting through two sessions in detail. After several more sessions, we'll reconsider the idea, as we have worked it out so far, and make variations upon it until we reach a satisfactory result.

DECISIONS ABOUT COMPOSITION

To clarify my compositional problems, I make diagrams before I start a painting and lots while I am working on it, but I've given up the procedure of making a careful thumbnail sketch that I then laboriously enlarge. I have found that I use up too much enthusiasm in the preparation of something that is altered in the long run.

I do advise you to use a much larger canvas than you think necessary. The reason is that for compositional purposes, to heighten emphasis, the painting may need to grow in one or more directions. If you have the space, you can accommodate these needs. Nothing is more agonizing than having to start all over again because you realize you need another four inches in one direction or the other. And it's been my experience that one finds out these requirements only during the actual painting process. Advance sketches won't solve all these sudden ideas or revelations that come when you are working.

If you make a simple sketch beforehand and are planning a full-view face, the center of the rectangle should coincide with the center line of the nose. If you're planning a three-quarters view, the center of the rectangle should run through the cheekbone of the near side of the face. This guide will help you to center the image since three-quarters views invariably tend to slip out of the picture.

Since you will use a canvas larger than your planned design, the unused border will allow you to realign your painting later on if you want to make changes. Although a portrait doesn't have to be centrally placed, the space around the face should be planned and should not look like an accident.

The initial idea is a portrait of a young woman with dark hair.

Allow space around your sketch to permit possible growth of the image.

For a full view, the center of the rectangle coincides with the center of the nose.

For a three-quarters view, the center of the rectangle coincides with the nearer cheekbone.

A border allows for adjustment of the image.

A sketch will help you to position the image correctly, since invariably three-quarter views tend to slip out of the picture.

DECISIONS ABOUT COLOR

At this early stage, let's make some preliminary decisions about the colors you'll be using in this simple portrait. Although it will have few elements, they must be part of a harmonious whole. You can't paint a person's face and achieve unity with the rest of the painting without getting the background, clothes, and hair right as well.

Let's decide tentatively on Indian red for the background, burnt umber for the hair, and ultramarine blue mixed with white for the shirt. But heavens! What a crude, rather violent blue it is next to the other two colors. Let's tone it down a bit by adding some raw umber and mixing it into the blue. That's more like it—a more sub-

dued blue that harmonizes with, and is similar in value to, the Indian red background.

Now for the flesh color. You will need at least three different values for the flesh plus three related colors, two warmer for the cheek and lips, one cooler for the neck and forehead. For the lightest flesh value, mix yellow ochre and white with a touch of alizarin crimson. For the middle value, add some raw umber to the above mixture. For the darkest value add more raw umber to the middle-value mixture. For the warmer light pink color, use yellow ochre, alizarin crimson, and white; for the warmer dark pink color, use more alizarin crimson, a little raw umber, a little yellow ochre, and white. For the cooler color, use yellow ochre,

very little alizarin crimson, more raw umber, and white. Remember, skin color is affected by the other colors in the painting. What looks like a cool flesh color against a red background will become a hot flesh color against a blue ground.

For the shirt, you'll need two values of blue. For the lighter value, lighten the basic blue with a warm flesh color. Don't just add white or the color will become very cold. White always cools things down. For the darker value, add more raw umber and ultramarine to the basic blue. The same idea applies to the hair. So that the hair doesn't become a flat dark mass, you'll need to lighten the basic burnt umber with warm colors, not white, to avoid making the girl gray overnight.

Indian red makes a warm background.

Ultramarine blue with white makes the first shirt color, but it is too strong.

Ultramarine blue with raw umber and white is a more subtle color.

The lightest-value flesh color is white, yellow ochre, and a touch of alizarin crimson.

The middle-value flesh color is white, yellow ochre, a touch of alizarin crimson, and a touch of raw umber.

The darkest flesh color is white, yellow ochre, a touch of alizarin crimson, and a little more raw umber.

A light pink is used for cheeks, nostrils, and lower lip.

A darker pink is used for the upper lip and as reinforcement for the nose.

A cooler color is useful for the neck and forehead.

MAKING A PAINTING

Having taken these tentative decisions about composition and color, you are ready to begin making a painting. We shall proceed together step by step through the first session. Then we'll see what needs to be done in the second session on another day.

FIRST SESSION

Your canvas is stretched. Your palette is set out before you with pure colors (straight from the tube) and mixed colors as we've discussed. I must emphasize that these colors are not prescriptive. You could obtain similar results using different mixtures of color. Ultimately, you must make the decisions. In art there is never one solution.

STEP 1. Dip a medium-size brush lightly in turpentine and then into one of your darker flesh mixes or umber—just enough to get a fluid brushstroke but not so wet that it's drippy—and draw with your brush the placement of the head, neck, shoulders, establishing the features roughly. Don't spend too much time at this stage; the drawing is only a guide and will be covered over immediately with paint. It's a good idea to establish the boundaries of your painting at this time, leaving a border for possible growth.

STEP 2. Stand about 20 inches from your canvas and take a big brush and cover the entire background as fast as you can. Paint fairly thin but don't use much medium; you're not making a watercolor! If you paint too thick, it will take ages to dry, as the first coat always dries the slowest. Subsequent coats, with a body of paint underneath, will dry faster and faster. Quickly cover the shirt with the darkest blue.

Now for the face. If you had painted the face first, it would have looked too dark—everything looks dark on pure white, and subsequent hues and values will tend to look too washed out. So cover the face with the middle-value flesh color, leaving your brush-drawn guidelines showing if necessary. Apply the lightest-value blue you've mixed for the shirt color to the model's near shoulder. The area will start to take on some form.

STEP 3. With a small-to-medium brush paint over the guidelines with your darkest flesh color, as these generally represent recessed areas: under the nose, under the brow, under the chin, the shadow area near the hairline, and the far side of the face.

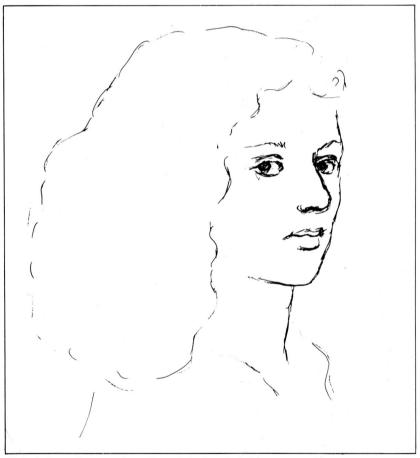

Step 1: Draw in a rough outline of the head and features.

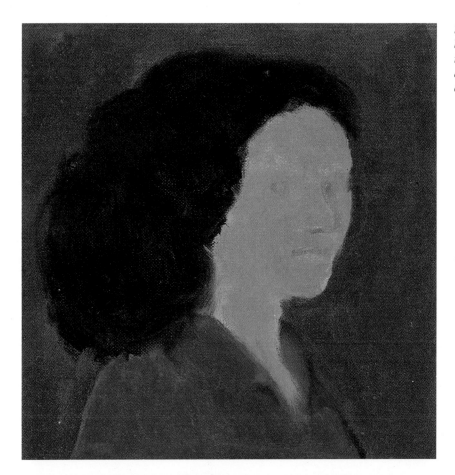

Step 2: Quickly paint in the entire background and the blue shirt. Cover the face with middle-value flesh color and the near shoulder with the lightest-value blue.

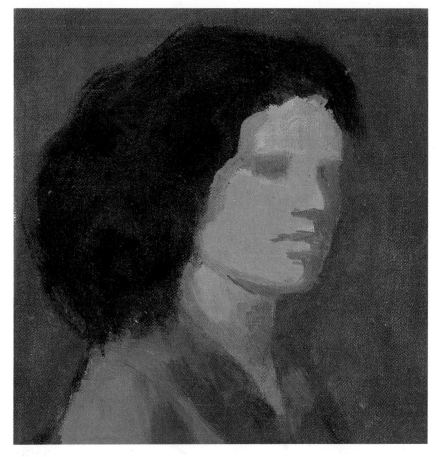

Step 3: Paint over the guidelines with the darkest flesh color.

Making a Painting

STEP 4. With a clean brush put the lightest flesh color on the projecting areas: the cheekbone, temple, tip of the nose, above the upper lip, and the chin. Add the warmest dark with a small brush for the upper lip and the lightest flesh color with a touch of alizarin crimson for the projection of the lower lip. Use a small brush to draw in the eyes with burnt umber.

STEP 5. Stain the white border around the painted part of your canvas with a wash of neutral color. Because of its intensity, white in the background can throw off all the colors and values.

Then walk away from your portrait and look at it from a distance. Think about what needs to be done to bring it to completion, and then model the form more fully. You can now intermix your colors by brush, darkening the flesh tone with some umber or alizarin crimson, adding cool colors around the eyes, or warm around the nostrils. A touch of pure alizarin will define and separate the lips further. If you find the paint becoming too slippery to work with, blot off some of the surplus with a rag.

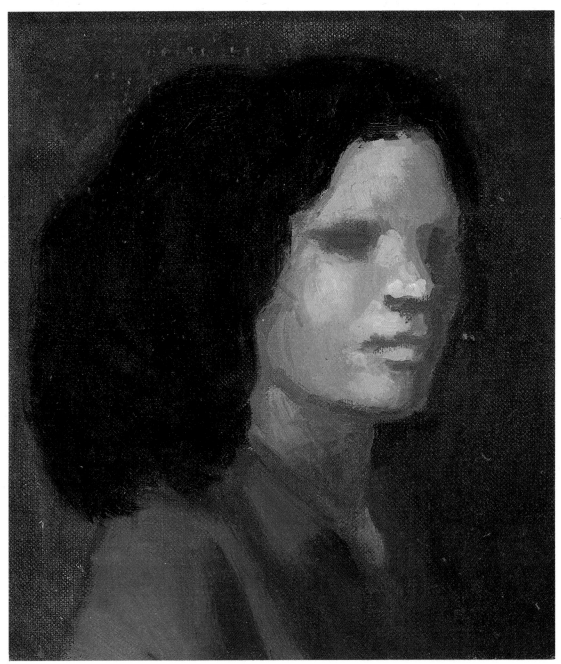

Step 4: Paint the lightest flesh color on the projecting areas.

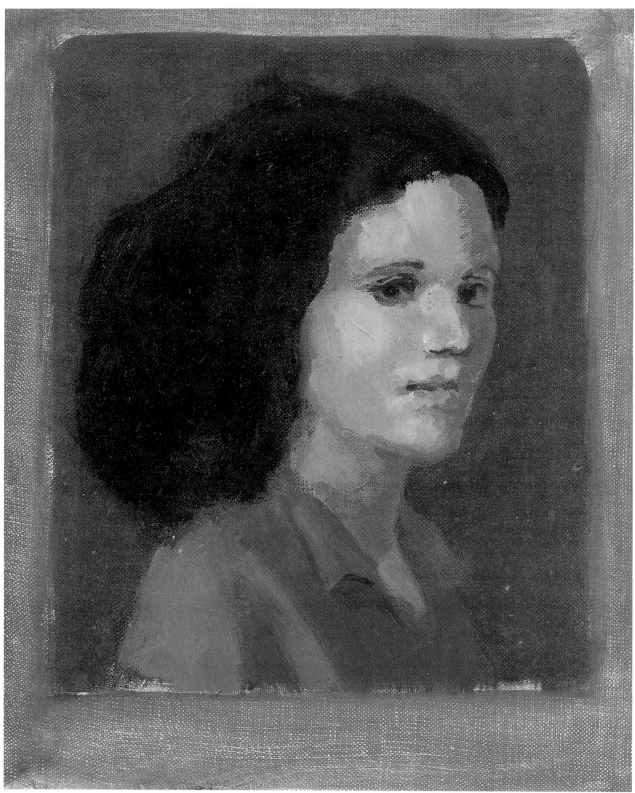

Step 5: Cover the unpainted border around your portrait with a wash of neutral color so that the white will not distort the hues and values.

Making a Painting

STEP 6. Finally, put a strip of masking tape around the painted area. The painting is now, in effect, framed. It has a defined edge but does not call attention to itself.

SECOND SESSION

Have you been able to leave your painting alone for a day or two? Is the paint dry—or at least no more than tacky to the touch? Of course, you can paint on new soft paint, but painting over the first coat before it's completely dry means that you risk slowing down the

drying time of the first layer of paint. You can hasten drying time, however, by dabbing over the whole area with clean, dry, large housepainter's brushes. Use a different one for each area of color or you'll be dabbing blue on the face and flesh color on the hair! This method leaves a faint, textured surface that I find pleasing, and the microscopic air holes made by the hairs of the brush help the paint dry faster than does a smooth surface.

So, let's assume that your painting is dry enough to resume work. You've set out all your pure colors

and paint mixtures on your palette again. At this juncture, I suggest you go to the far end of the room, sit down, and take a long look at your work. Perhaps you like it just fine. Perhaps, as so often happens, you're just not pleased with the direction the painting is taking: The paint looks smeary; the face is too pale; there's too much hair; the background's not interesting. Cheer up! An oil painting can be endlessly changed.

This is the time to add another color or two to your palette. To eliminate that rather pale complexion, but without making the model

Step 6: Define the edge of the portrait with masking tape.

look too sickly (from yellow ochre) or too pink (from the alizarin crimson), try adding a touch of cadmium orange to the flesh colors. However, it's still a good idea to reserve some of the pink mixtures for the lips, cheekbones, and nostrils.

Perhaps you feel that the background should change in color rather than in value from one side of the picture to the other, so you decide to add a touch of cadmium orange to the Indian red for one side or to squeeze out a new color, such as Mars orange. Don't forget you are painting everything at once. You are relating the face to the background, the background to the shirt, and so on.

At this stage, you'll probably want to start remodeling the features all over again. Pay special attention to the far contour of the face and paint it and the background together. Then go over the entire face area with a new layer of paint. This time the subtle differences between the colors and values should become more apparent—the cool color in the neck and around the eyes in contrast to the warm-colored surrounding skin tones. If that pink of the model's cheek becomes too dark in value, her cheekbone will either recede or look as if she is wearing heavy makeup, or both. Be careful not to make the lips too dark a pink—a lipsticked mouth is the devil to make soft and natural looking. Establish some shape to the hair by cutting it back with background color; then model it by adding a lighter value. The accompanying chart shows you various ways to warm or cool flesh colors.

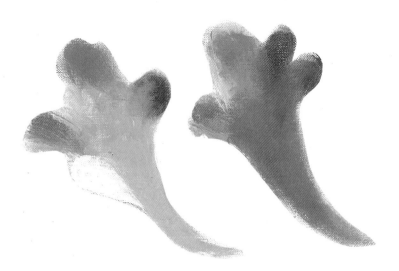

Cadmium orange added to flesh-color mixes enlivens the complexion.

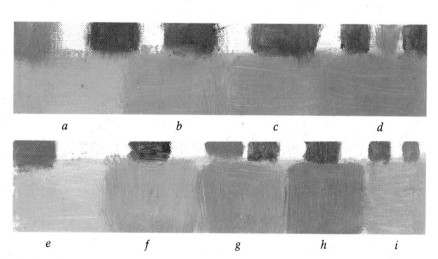

Flesh colors may be warmed or cooled depending on what colors are added to the basic mix. Yellow ochre, alizarin crimson, and white (a) may be cooled with raw umber (b), warmed with more alizarin (c), or warmed and darkened with more alizarin, ochre, and raw umber (d). Cadmium orange and white (e) may be cooled with raw umber (f), warmed with orange and raw umber (g), warmed with alizarin (h), or warmed with alizarin and orange (i).

Making a Painting

Throughout this process, don't forget to step back from the picture and observe it from a distance. Or look at it in the mirror—frequently. Do the whites of the eyes pop out? Lower the value. Raw umber and white make a good gray, whereas black mixed with white would be too cool in this painting. (But in very cool-toned painting, where there are a lot of blues, a gray made of black and white could look warm.) Does the face look flat, with no value changes? Are the light-valued areas too light and spotty so that the

flesh looks more like porcelain? Is the alignment of features correct? Is the near eye too close to the nose? Is there too much face on the far side? Is the space on the near side of the face insufficient—two planes, remember? *Check in the mirror again and again.*

Suddenly you get an idea about the background: Why not put in two horizontal bands for added interest? You try a dark blue but think it contrasts too much with the red. It's just too aggressive. You try a light blue. But it's too light in value and bright in color. It

jumps out, won't stay behind the figure. On your third try, you succeed by brushing in a dull, low-value green (phthalo green with a touch of Mars orange); this mixture stays in place behind the model and makes a pleasing juxtaposition with the Indian-red background.

At this stage, you may very well decide to continue working out your idea to a complete painting. If you are pleased with the color, size, and value relationships, that'll be just fine.

The white of the eye on the left is white touched with a little raw umber. The white area of the eye on the right is a mixture of white and a bit of black, a combination that creates too much contrast and causes the eye to jump out. If you look at these eyes upside down (by turning the book upside down), you'll see the difference immediately.

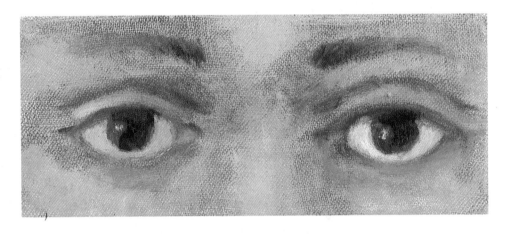

On a background of Indian red and Mars orange, a dark blue band contrasts too much, a light blue band jumps out, and a band of thalo green dulled by Mars orange stays in place.

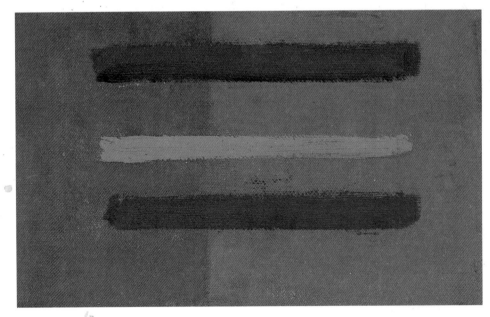

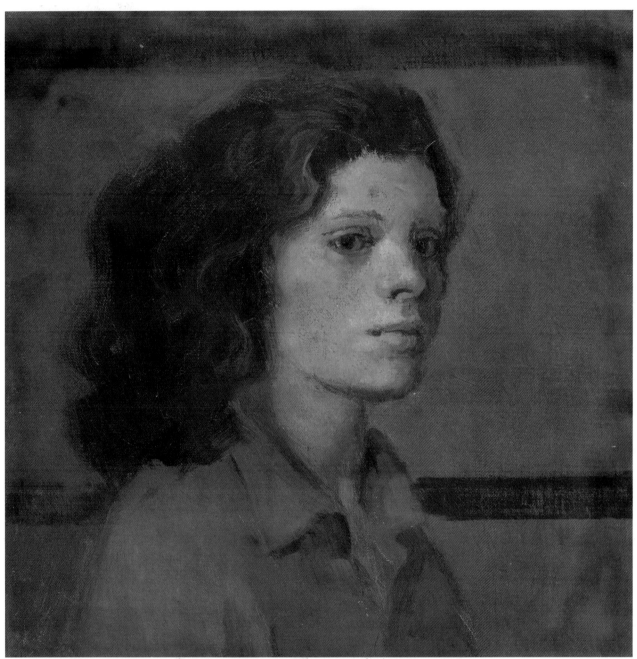

A band of dull green enlivens the Indian red background but remains behind the model.

CHANGING A PAINTING

Let us say, however, that you have completed three or four sessions developing your idea, and the paint is dry. You have taken a long look at your work from the back of your studio, and you find you're still not at all satisfied. Don't despair! Dissatisfaction can be the very best propellant to creativity. For if you like the painting, you won't take bold chances with it, and often wild experiments open up all sorts of possibilities. The following variations on your initial idea will take you on a painting journey—to discovery.

VARIATION ONE: CREATING MOOD WITH GLAZING

You have decided to change the colors, values, and feeling of the painting by covering it with a dark glaze of alizarin crimson mixed with black. To glaze, as you read earlier, the surface has to be completely dry, and there must be a layer of solid paint to glaze over. Otherwise, the damp underpainting will cause the surface to smear.

On your palette, make a large puddle of medium and the reddish black mixture. Be sure the alizarin and black are well mixed so that you don't get streaks of one or the other. Then with your biggest housepainter's brush cover the entire picture with the mixture. Don't panic because the figure is vanishing. It's there all right, looming through the dark, and if you wipe off the glaze, there it is—rather ghostly but still intact.

Now's the time to paint in your new version. With a series of dry housepainter's brushes, start dabbing off the glaze to allow the image to return, beginning with the lightest parts. When the figure "reappears," you'll see her but in different, cooler colors. The shirt is now a lovely subtle gray violet, but the face is far too dark. The forehead area shows you the untouched glaze area.

To remodel the light parts of the face in relation to the new value-color scheme, mix up a new set of flesh colors stronger than the first lot but darker in value. To test the new colors, put a little paint on the tip of a palette knife close to the painting or hold the knife well away from you, with one eye closed, to make a blur of color against the painting behind it. Then begin to remodel the face, leaving the glaze in the shadowed areas, but using no medium, since the surface is still moist from the previous application of glaze, even if dabbed off. To gradate the new paint into the rich transparent shadows, use a fairly large, dry housepainter's brush. If you can wait a day for the glaze to dry before going on to remodel the face, you'll find the job a lot easier. However, I can seldom wait!

Now you think a few more light touches are necessary for such a dark painting, to balance the light areas of the face. Using your sable watercolor brush, paint in the separation line between the lips and the hoop earring that you decide to add for extra sparkle. Then make the shirt collar lighter with a mixture of raw umber and white.

Perhaps now you have arrived at a result that you're pleased with, so you decide to extend the painting on both sides. All you need to do is take off the framing tape; add a dark red to either side, glazing it when dry, in order to blend into the existing glazed background. Once you've added these areas, redefine the portrait with new tape.

If you're pleased with the picture at this point—terrific. If not, consider other possibilities . . .

The whole painting is covered with a dark glaze of alizarin crimson and black.

a

b

c

d

A lighter color for the shirt collar is a mixture of raw umber and white.

New flesh colors are various mixtures of yellow ochre, burnt umber, and Indian red (a); yellow ochre, burnt umber, and alizarin crimson (b); white, yellow ochre, and cadmium orange, and alizarin (c); and Mars orange, raw umber, and yellow ochre (d).

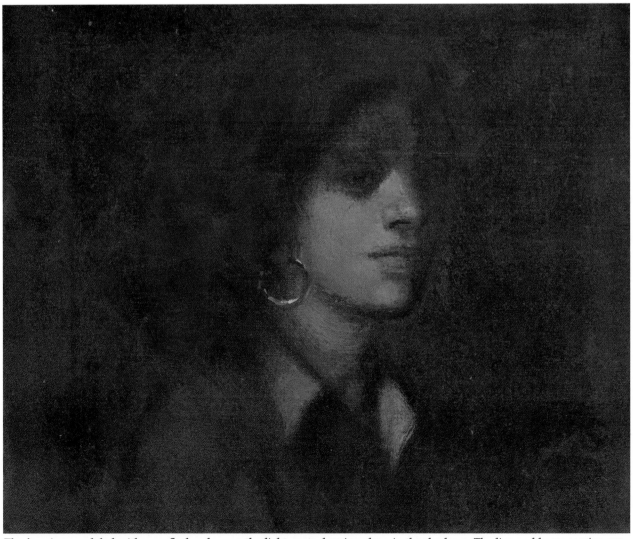

The face is remodeled with new flesh colors on the light parts, leaving glaze in the shadows. The lips and hoop earring are defined. Perhaps this version is satisfactory and the painting may be considered completed.

Changing a Painting

VARIATION TWO: REVERSING FIGURE AND BACKGROUND

You rather like the dark painting but perhaps feel it is too dramatic for the subject matter. Think about reversing everything! Instead of a light-valued, strongly illuminated face set against a dark background, you decide you want a very light background, against which the face will look darker.

To achieve this effect, cover the entire background with a thick mixture of raw umber and white. This gives you a soft, rather warm gray. Note that this color looks very different than it did when it was used for the shirt collar and had picked up some of the glaze. What a very different effect changing the background has made!

Your next thought is you'd like to bring back those background stripes very faintly, so you scratch through (with your palette knife or the wooden end of your brush) the gray background to reveal the green underpainting beneath. The result is a lacy green pattern.

Stepping back from your painting, you discover that you don't like the violet of the shirt left over from the dark variation one, so you go back to a soft, more greenish blue (the ultramarine mix) but with more raw umber. However, the flesh colors now look a bit hot and red against that cool greenish gray background, so you cover the entire face with a thin glaze of raw umber. This flattens the modeling a little and gives the model an instant tan. You now have an emphatic form with a strongly silhouetted contour.

To avoid a monotonous, cut-out look, you soften the hair into the background at the shoulder. To break up the mass of dark hair and to add a needed color accent, you add a headband in a much stronger blue than the shirt. You are careful to keep the headband in the same value range as the hair so that it doesn't come forward and call too much attention to itself. To further lighten and model the dark mass of hair you add a lighter brown color composed of Indian red, yellow ochre, and black, keeping it warm to avoid instant age.

One last decision is to enlarge the painting vertically, so that more background appears above the top band. So off comes the strip of tape along the top border. You then brush in more of the gray mixture and replace the tape where you think it looks right.

If you find you like the results of your changes, this version could well be your finished work. But just to show you some further possibilities in developing a painting, I'm going to assume that you are still searching for some statement pictorially about this girl but you are not sure what—until you've made it!

Against a light gray background the figure looks dark. Scratching through the gray to reveal the green underpainting creates lacy green stripes.

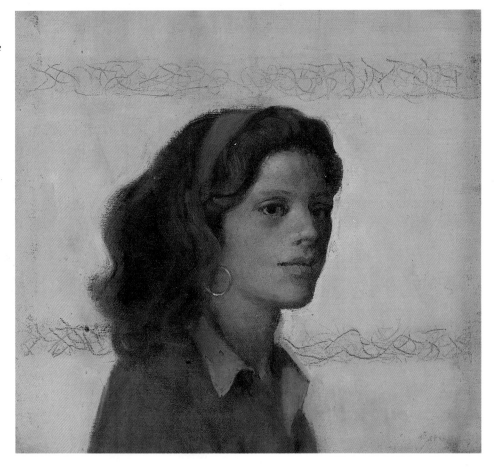

VARIATION THREE: CHANGING THE COLORS

Again, after a lot of stepping back and looking at your painting from a distance and in the mirror, you feel that this interpretation, although there is a lot you like about it, is too strong, too stark, with too much contrast. Perhaps it is not young enough in feeling. So you experiment with a totally different color scheme. You try a light-colored background—a cadmium orange. But it's too bright and comes forward much too much. You tone it down with some raw umber, mixing up the mixture with your palette knife as usual, adding even more umber for the lower part of the picture.

You also decide to reduce the height of the painting, eliminating the top band and, once again, adjusting your framing tape. Now the lower stripe changes to an ochrish color, which is almost the same value as the orange.

The ochre has become a predominant color element: you see it in the sleeve (yellow ochre and white) and the headband. The image is also bisected vertically and horizontally by yellow, the verticality emphasized by the leftover blue of what is now a vest.

Within this new color scheme, the hair seems much too flat and dark, so it is radically lightened with a mixture of burnt umber, raw umber, and yellow ochre.

The face also seems flat and too uniform now that there is less contrast with the background. Although brighter in color, the background is now a darker value than the previous gray. So you need to build up the face again, bringing forward the lighter, prominent parts with paint to relate it to the new colors and values. You think back to the light collar framing the face in variation one, so to place your eye solidly in the center of the composition, you decide to make the collar somewhat larger and a luxurious, creamy white.

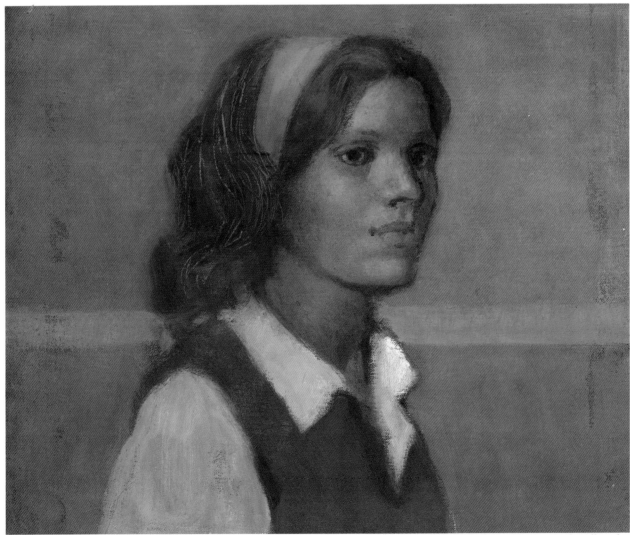

A new color scheme has a dulled orange background and dominant yellow ochre shapes (the lower stripe, the headband, and the sleeve). The face is modeled again, and the collar is made larger and white to attract the eye to the center of the painting.

Changing a Painting

VARIATION FOUR: NEUTRALIZING AND REMODELING

After all your efforts, you find you still don't like your work. You decide to eliminate the entire painting by covering it over with a neutral layer of white mixed with a little raw umber.

Your painting's transformed. A faint, ghostly image is still showing—and it looks rather interesting! The figure is a symphony of off-whites with a warmer off-white background that has picked up some of the slightly moist orange.

With enthusiasm you dash to your palette to set out some new color mixes. You decide to give the model a white shirt and headband and rub off any remaining white on her face and hair. Both look bleached out as if you had placed a layer of opaque film over them—-a nontransparent glaze. Now you re-paint the face and hair in new light colors.

Suddenly an inspiration comes. You decide to add some fragile sprays of jasmine flowers in the lower right area and place the figure asymmetrically (not centrally) by altering the boundary strips. The sprays of jasmine are made up of various mixtures of permanent green light, cadmium orange (or Mars orange), plus touches of white for the flowers. Now you have realized the feeling you were groping for—the delicate evocation of youth.

The painting looks good to you, but you think it still needs some work. The face seems a bit too pale all over, and you'd like more definition of that far contour. Begin by brushing in a faint raw umber glaze over the entire face and hair area, running it over and across the contour and into the background in order to avoid a hard edge of the glaze. Then dab it off with a dry brush.

Covering the painting with a neutral layer of white mixed with raw umber and gray produces a symphony of off-whites with a ghostly image showing through.

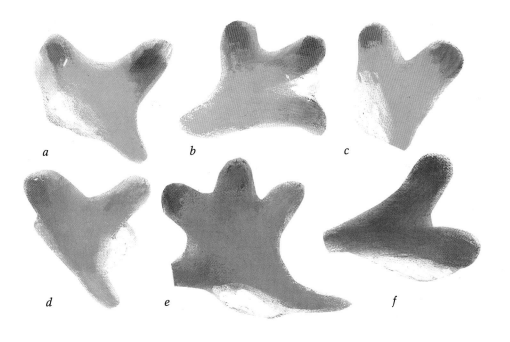

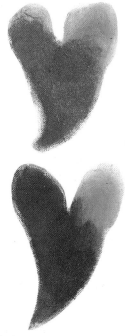

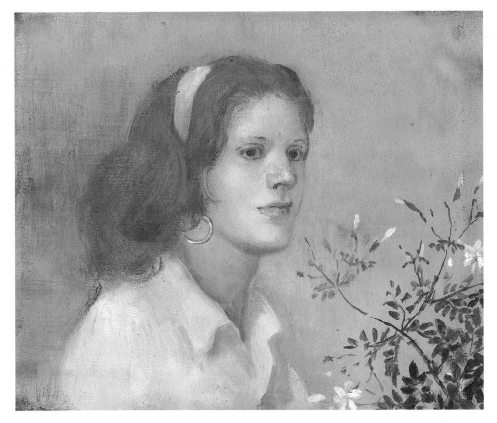

New light flesh colors consist of white, cadmium orange, and alizarin crimson (a); cadmium orange, alizarin, white, and yellow ochre (b); white, cadmium orange, and raw umber (c); cadmium orange, yellow ochre, and white (d); white, cadmium orange, alizarin, raw umber, and yellow ochre (e); and white, raw umber, and cadmium orange (f).

Various greens are composed of Talens green light with cadmium orange (top) and Mars orange (bottom).

By expanding the canvas area on the right, we have altered the placement of the figure, making the composition more asymmetrical and less centered. With the addition of fragile-looking plant life, the portrait itself begins to suggest more delicacy.

Changing a Painting

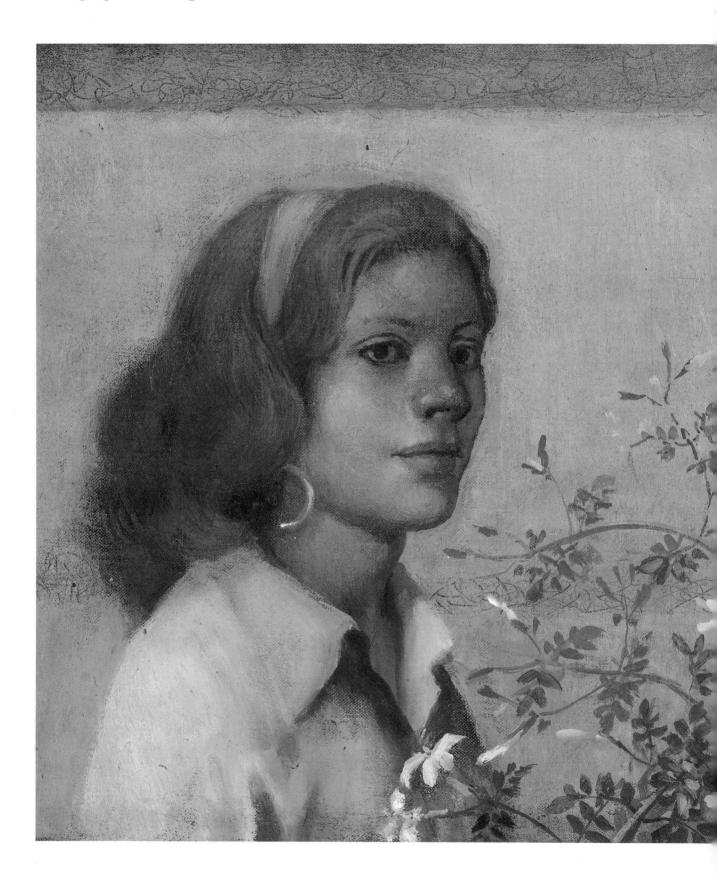

With the application of the glaze, the face looks rather flat and seems too dark in the context of the other colors. So you remodel again, using similar light flesh color mixtures to the ones you had used before. To paint in the details of the features, use a small sable brush and a 1-inch housepainter's brush for blending areas. A small sable is excellent for using around the eyes and for the line separating the lips; for the lips themselves, a small bristle brush works best because a mouth goes rigid very quickly if it is too sharply defined.

Stepping back, you wonder if a cooler white would work better for the headband, so you mix up a batch of black and white paint with your palette knife and find in the context of this painting that it looks almost blue.

The adjusted headband color looks good so you apply the same color to the shirt but under the collar, you use a darker version, almost a charcoal color. You bring back the background stripes in this version by scratching through to the underlayer and then scumbling over it with a mix of gray and yellow ochre.

The jasmine plant is developed further with at least two values of green. As the plant grows, so does the space on the right side of the painting. Where the plant appears in front of the girl, it establishes another plane, instead of having them side-by-side as before.

The painting has evolved to its finished state: an asymmetrical composition with a horizontal format. When the glaze on the hair is tacky, you lighten some parts, again using a dry scumbly paint to convey the effect of fine tendrils of hair. Then, when you start niggling around the painting and fearful of any changes, you'll know that at last it's done. Restretch the canvas on new stretcher strips to accommodate its changed proportions.

I want to emphasize that at any time in this series of variations you could have carried the painting to completion, enlarging, reducing, or adding new elements that I haven't suggested—the decision is yours, not mine. You could have arrived at the same color mixes by using different colors from those I've used. These variations were presented only as *possibilities*, to show you how an idea for a painting can change and grow.

A raw umber glaze is applied and dabbed off. The face is remodeled with new, light flesh colors, and the details of the features are picked out with a small sable brush. The headband and collar are painted a cooler white. The background stripes are rescratched and scumbled over. The jasmine plant is more fully developed.

PART 4

DEVELOPING A PAINTING

The following account is a diary of the development of two paintings. It is intended not so much to show you specifically how to paint as to give you some idea of how the creative process works for me.

You'll notice that in the beginning the time lapse between entries is quite short; that is because the painting is changing rapidly in its infancy, but as it develops and matures, the entries become more and more widely spaced. The daily practical decisions about drawing, color and value relationships, composition, and costume, which build the esthetic result, wouldn't be apparent in a photograph of each day's work. Also some bad days were almost entirely occupied with eliminating, repainting, and eliminating again.

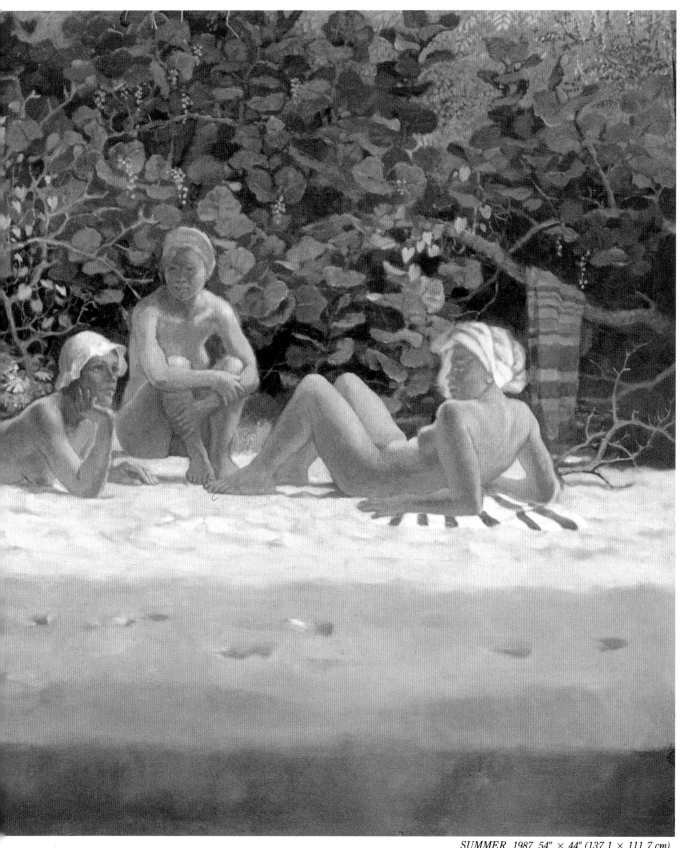

SUMMER, 1987, 54″ × 44″ (137.1 × 111.7 cm).

FIESTA

My painting *Fiesta* was the result of a rapturous visit to Guatemala. At Lake Atitlán I visited a remote Indian village, San Antonio Palapó, when the Indians were celebrating their annual fiesta.

Bumping over a dusty road in an ancient taxi for about an hour, I arrived in another century. The steps up to the church were a cascade of red, with all the women and most of the men in traditional local dress. The women wore red and white striped *huipils* (blouses) and long black skirts. Their hair was braided with red ribbon, and yards of yellow beads were around their necks. The men were also in red-striped shirts; they wore red kerchiefs around their heads and black kilts. Indians from other villages could be identified by their local dress, too, but there wasn't a tourist in sight.

PHOTO REFERENCES AND DIAGRAMS

I used my camera as a sort of instantaneous sketch pad. I was able to photograph fairly unobtrusively as everyone was busy watching the festivities. I was entranced by the persistence of traditional appearance and habit as yet undiluted by modern ways.

Here are some of the photographs I took, to give you some idea of what I saw. They were not intended to be art photographs, simply reference notes. You will recognize some of the figures later on in the painting.

I prepared a large canvas 48 inches high and 66 inches long, but I made no preliminary sketches beyond the two simple diagrams. The basic composition is a wide triangle, surmounted by a small rectangle. In retrospect I realize that this shape persisted in my conception of the scene because it is the shape of the great Maya ceremonial structures: a wide pyramid with a temple at the truncated top.

Reference photographs show Indians at a fiesta at San Antonio Palapó, Guatemala.

Preliminary diagram of a triangle supporting a small rectangle suggests an ancient Mayan pyramid with a temple on top.

This diagram is another version of the triangle and rectangle composition.

The ancient Mayan pyramid at Tikal, Guatemala, still supports a temple.

DAY 1:
BLOCKING IN COLOR

On my first day of painting, with my photographic notes spread out around me, I plunge into the painting. Here is the result of the first morning's work. As you can see, it is almost monochromatic in the use of red. I need greater variation in color, in both hue and value. The painting has already become a different size from that of the canvas. Now it is 40 by 60 inches.

The predominant red color of the first day's effort was determined by the Indians' red-striped blouses and shirts, but it does not give much variety.

Fiesta

DAYS 2 AND 3:
REFINING COLOR

From now on I plan out my colors with more care. The first coat of paint on the white canvas doesn't allow much subtle variation, but every day now I shall be preparing my own mix of colors before I start painting.

Here are samples of some of the colors I mixed. They all look dark against a white ground. Here are samples of the same mixed colors on a tinted ground, which makes them look lighter.

To unify several figures in the painting I can use an identical base color but produce a variation by altering the color of the stripes. The base color, cadmium red light, is changed optically by adding blue or green stripes.

Cadmium green is mixed with cadmium scarlet and a little white.

Cadmium green pale is mixed with alizarin crimson and a lot of white.

Cadmium red light is mixed with cadmium green light.

Cadmium red is mixed with cadmium green and alizarin crimson.

Indigo is mixed with Sèvres green, raw umber, and white.

Indigo is mixed with Naples yellow deep and white.

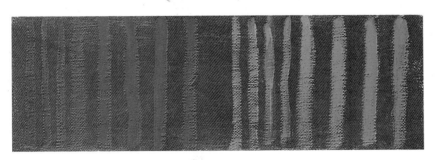

A base color (cadmium red light) is changed by neighboring colors. Blue stripes make it look violet. Green stripes make it look orange-green.

DAY 4:
ADJUSTING THE COMPOSITION

On the fourth day I'm bothered by that large expanse of blank wall with nothing on it. I tried an alcove with a boy sitting inside, but it looked idiotic. So now I try a horizontal architectural element to hold the triangle of massed figures on the steps in place. The painting has grown laterally, measuring the full width of the canvas—40 by 66 inches.

I add more blues and whites to the figures. I produce a sense of depth in the dark church interior by adding a recession of lighted windows.

DAY 5:
ADDING PATTERN

By the fifth day I'm mixing up my special colors daily and introducing more and more varieties of red, as I define and organize the figures. A bright magenta has appeared in a couple of places, and I try texturing that troublesome church wall.

I lower the top of the painting by about two inches and change the church windows.

Then, to give some sense of pattern, which, after all, is an essential component of this scene, I add stripes to a lot of the costumes. It's always very difficult to add a lot of pattern later on in a painting that has been developed as plain surfaces, so one has to try to suggest all the components all the time from the very beginning. In a painting, everything affects everything else.

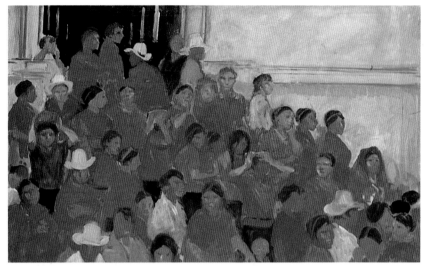

A horizontal architectural element is added to hold the triangular mass of figures in place.

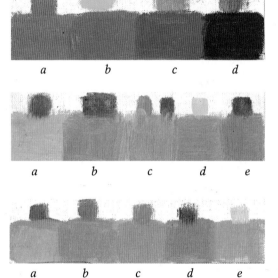

A base color of cadmium red (a) is modified by adding Talens green light (b), permanent green (c), or thalo green (d).

A base color of raw sienna and white (a) is changed by adding more raw sienna (b), orange and alizarin crimson (c), Talens green light (d), or raw umber (e).

A basic color of cadmium red deep and white (a) is altered by adding yellow ochre (b), orange (c), raw umber (d), or Talens green light (e).

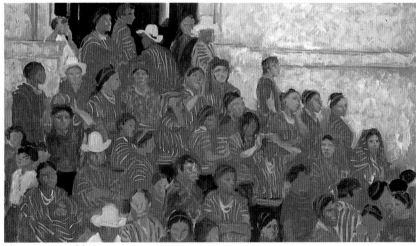

Stripes are added to many costumes to give pattern.

Fiesta

DAY 7:
READJUSTING THE
COMPOSITION

On the seventh day I decide I don't
like that horizontal element on the
church wall. It's too aggressive in
the painting and looks as if it's
there because I didn't know what
to do with the blank area.

I eliminate the horizontal and try
the wall in different colors—ochre,
pink, gray. They don't work and
they are also untrue to my impres-
sion, which was of a colorful mass
of people against a very light back-
ground.

I continue working the composi-
tional relationship of the figures,
using related colors to link them,
stripes as directions for the eye,
and sudden changes in color and
value to mark points of emphasis.

Here are some closeups of areas
to show you how they change as
the painting progresses. By this
time the painting has grown at the
top, so that it is now 42 × 66
inches.

*The wall is laid in with
scumbles of creamy white.*

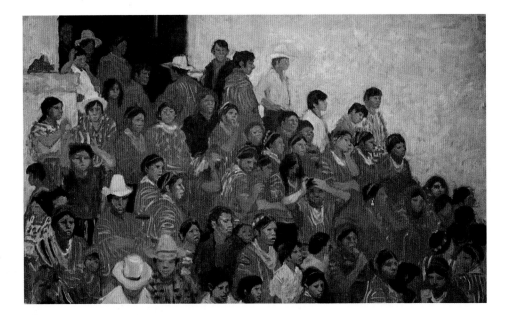

Stripes are added to relate figures and provide points of emphasis.

*Stripes and checks add pattern to plain
forms.*

DAY 9:
ADDING A DIAGONAL SHADOW

On the ninth day, I squeeze out a lot of white and start painting out the wall . . . but wait! A bit of a darker tone on the right side suggests something. What about a diagonal shadow so that the light expanse is broken up? I mix a greenish gray to intensify the diagonal, and I like the result.

DAY 14:
REORGANIZING THE COMPOSITION

By the fourteenth day I have a greater variety of colors while still preserving red as the dominant hue, but I need to organize the composition of the figures more carefully. The eye should be led from point to point but not forced to follow a rigid design, since, this

is, after all, a painting of a mobile crowd.

Using the diagonal suggestions of the wall shadow, I darken the lower right where it connects with the shadow and the skirts of the center group of women, and I add more dark elements leading up to the church door. This begins to trace the path of a V as a counterpoint to the pyramid formed by the figures.

A mixture of indigo, Naples yellow, and white makes a shadow for the wall.

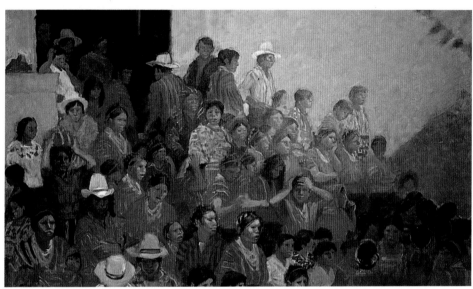

A diagonal shadow on the wall directs the eye back toward the center of the scene.

Adding dark elements in the lower right and the center leading up to the dark church door strengthens the composition.

A V pattern emerges, counteracting the pyramid shape formed by the figures.

Fiesta

DAY 19:
ADJUSTING SCALE AND
CONTRAST TO SHOW DISTANCE

Five days later I find that the scale of the figures within the painting needs adjusting. In the early stages they were all roughly the same size, which gave more of a frontal, frieze effect than a sense of people standing in deep space. I'm now reducing the size of the spectators on the right side and also those that recede up the steps to the church door so that they seem farther away. I reduce the contrasts of color and value on the right side—the strongest dark on the right would appear as a light on the left. Softened colors and values are another way of indicating distance.

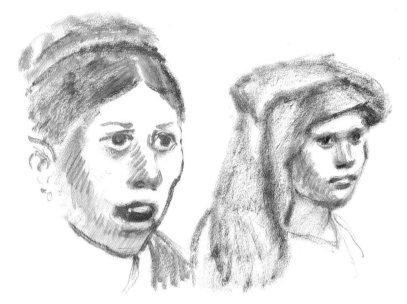

The figure on the right has been made smaller than the figure on the left, a change in scale that produces a sense of depth.

The contrasting colors and stripes on the figures on the right are lightened as a way to indicate that they are farther away from the viewer.

DAY 22–25:
REPEATING DIAGONALS, HORIZONTALS, AND VERTICALS

On the twenty-second day I'm still refining my figure relationships. Because the composition is so dense, every time I move one figure or alter its size, it affects the figure in front and the ones behind and beside it—and ultimately the whole design. Every day it seems that I am moving around half the population of San Antonio Palopó.

The architectural element on the church wall has returned but in a much paler version, and its impact is lessened by the importance of the cast shadow and of the shadows of the fluttering bunting. The diagonal of the shadow is repeated on the church door.

In developing the figures I try to make use of the pattern in the costumes as repeat elements to integrate the composition. The steps are thus repeated in the horizontal stripes, and the verticals are repeated in the door moldings and in the insistent wide stripes of the shawl in the center.

DAY 32:
MODELING FABRIC

In this painting I didn't want too much emphasis on the folds of the costumes because I thought they would overcomplicate an already densely packed mass of figures, so I used the minimum of modeling. The use of stripes, spots, or other patterns, however, will invariably have a flattening effect on the underlying form of the figure, even if it is fully modeled. To return a figure to its full three-dimensional form, let the pattern dry, and then glaze over the darker parts of the figure that you have already established. For even a greater sense of volume, you can put a very thin scumble of a much lighter base color over the lightest part of the patterned area.

The diagonal formed by a shadow is repeated in a diagonal on the church door.

Repetition of the horizontal architectural elements by horizontal stripes in the costumes and of vertical elements by vertical stripes helps integrate the composition.

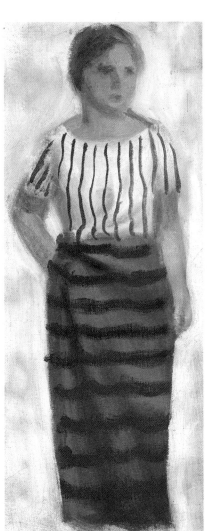

Patterned material reduces the sense of volume.

A glaze over the darker values of a form will restore a sense of volume. A scumble of light color over the lightest value will also increase the roundness of the form.

Fiesta

DAY 45–55:
UNIFYING MASSES AND
ADDING A GLOW

To give areas even greater unity, I glaze over parts of the composition, using mixtures of sap green and alizarin crimson in the darker areas and cadmium green light with alizarin in the lighter areas. And I used creamy scumbles over the lightest section on the right. The cadmium green light mixture is the same as the basic mix used earlier, but without the white.

Ten days later I've continued to change and modify the population of my painting, eliminating some people and adding others. Everything I do has its repercussions throughout the painting.

I've now put a very thin glaze of raw sienna mixed into a tiny bit of burnt sienna over the whole painting to give it a glow. The glaze also prevents a confrontation between the reds and the blues.

A glaze of sap green mixed with alizarin crimson is used on a white ground.

A glaze of cadmium green light mixed with alizarin crimson is used on a white ground.

A glaze of raw sienna with burnt sienna looks luminous over a white ground.

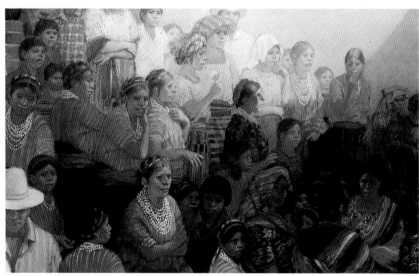

Complex patterns are subdued and unified with glazing.

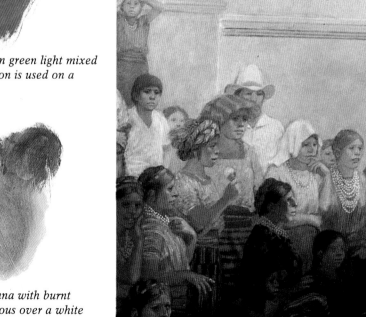

In this detail a sienna glaze reduces the tendency of the red and blue to fight each other.

REFINING THE FIGURES

Naturally throughout the eight weeks I've been working on *Fiesta* I've looked at it upside down, in daylight and twilight and artificial light, and about every five minutes in the mirror to find a fresh viewpoint. As I worked, I kept seeing more things I should change, areas of careless work that were not just a matter of "lack of finish" but were sloppy drawing or not fully thought-out relationships.

At various times in the later stages of the painting I refined faces. I had a collection of more than fifty-five of them. The ones shown here I transferred from the painting to paper and superimposed directional diagrams so that you can see their structure and direction.

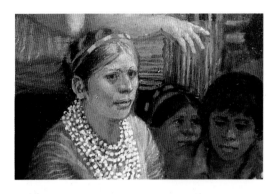 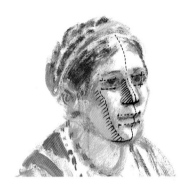

A woman in a striped shawl and ropes of beads looks off into space. The side and front planes of the face are diagrammed in this three-quarters view.

 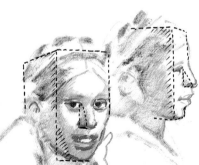

A woman wears a red head-band and colored ribbons braided in her hair. Her head is tilted toward the viewer, as indicated by the diagram.

 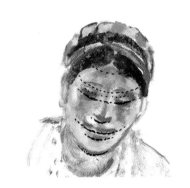

Two women with ribbons braided around their heads show three-quarters and profile views. The angles of the boxes emphasize the different angles of the heads in relation to the viewer.

 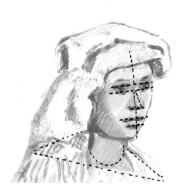

A woman folds a pink shawl on her head and lets the fringed ends fall over her right shoulder. In the diagram her head is tilted to the right and her neck fits securely into her shoulders.

Fiesta

FIESTA, 1987, 67" × 42" (170.1 × 106.6 cm).

FINISHED PAINTING

I hope this diary has given you
some idea of how a painting grows.
Fiesta isn't complete, I feel, but I'm
going to put it face to the wall for
now. I'll start something else and
then return full of ideas of what to
do next . . . perhaps.

Two months later I look at my
painting. I see all sorts of things I
want to do. I want to make the
wall a bit lighter, but then the
group on the steps may have to be
scumbled and overpainted lighter.
The central woman with her arms
folded does not look Indian—I
must change her cheekbone and
upper jaw. And so on . . .

SUMMER

The inspiration for *Summer* was a scene I see frequently from my house in the Caribbean. The lovely beach is bordered by trees and huge sea grape bushes, the type of foliage I've used in the background of the painting. Here is one of fifty or so drawings I made of the trees, branches, and leaves during the progress of the work.

My procedure for this painting was quite different from my normal method, in which I make only the briefest of diagrams and let the painting develop on canvas, as in *Fiesta*. For *Summer* I had made a large watercolor six months previously, in which the composition was fairly worked out. Then I decided I would prefer it in oil.

This crayon drawing of branches is one of many studies of trees and bushes made for Summer.

The watercolor version of Summer *became a preparation for the oil version.*

PRELIMINARY DRAWINGS

Having established the positions of my figures in the watercolor in the Caribbean, when I returned to New York, I hired several models and made drawings of the main poses and possible variations. I drew in pastel on tinted paper, rubbing out the lighter forms and adding white pastel for the highlights on the most prominent areas, in the technique discussed in part 1 on drawing (see page 38).

As you can see from the watercolor, the proportions of many of my figures were laughable. I ran out of paper on the left, so the fellow has the legs of a dwarf.

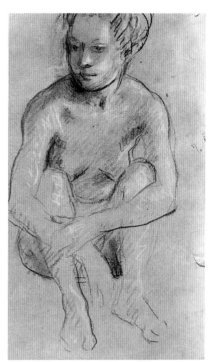

This figure study for Summer *was drawn in dark and white pastel on tinted paper.*

A minimum of dark and light pastel suggested the pose and volume of the right-side figure.

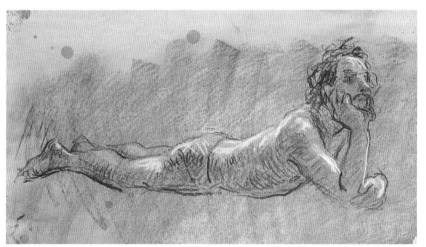

To sketch in the left-side male figure, I first covered the paper with brown pastel to provide a middle value. The model's form was then built up in white and dark pastel.

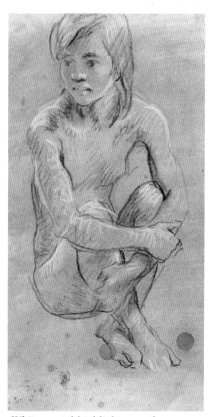

White pastel highlights another preparatory figure study on tinted paper.

Summer

DAY 1:
ESTABLISHING FIGURES ON
A COLORED BACKGROUND

I start work on a very large canvas, 50 by 72 inches, and center the group in order to allow space for the composition to grow in all directions.

I translate the three figures from my drawings into a warm monochrome modeled to establish the main lights and darks but with no variation in color as yet. These figures took about half an hour's work. I used a no. 7 flat and a no. 7 round and worked as fast as possible, since this is only a rough guide.

Next, using housepainter's brushes 3 inches wide, I cover the background with a dull green and add the sand colors that form bars at the bottom. I leave no area of the pure white canvas untouched. After another half hour the work is an unattractive, muddy-colored, slippery smear, so I cheer myself up by defining the possible border of the painting with white tape and wiping off the area outside my "frame."

The size of the painting has already been reduced from the size of the canvas; it is now 36 by 66 inches. To add fresh colors to this slippery surface I first rub out areas with my finger covered with a clean paint rag. This allows a new color to appear in a moderately clean version. Wet paint on soft wet paint tends to become a distressingly muddy neutral. As the paint surface builds up during the course of the painting, the colors start preserving their identity, even closely related values and colors.

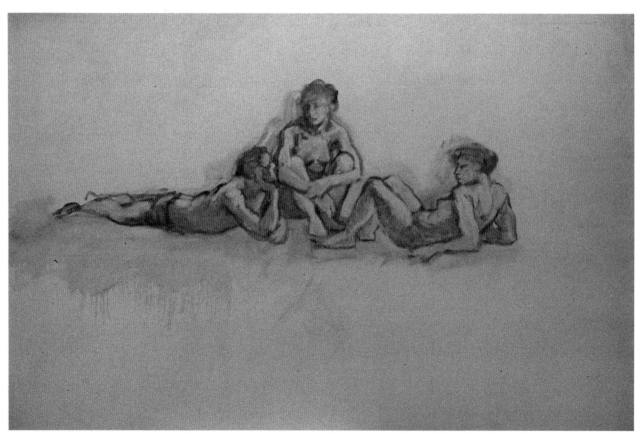

The figures are modeled in a warm monochrome to indicate the principal lights and darks.

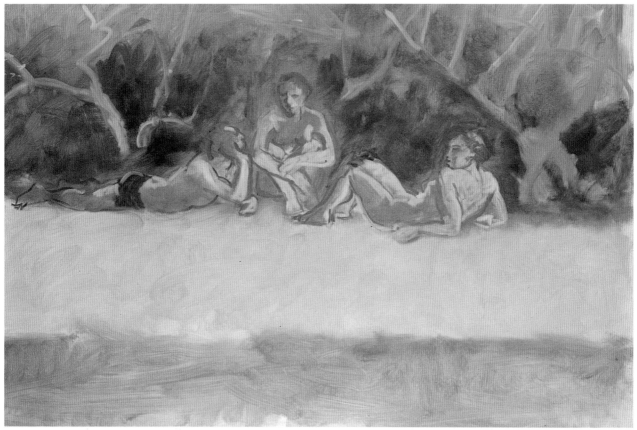

A housepainter's brush was used to fill in the background quickly.

This detail shows the areas where I have rubbed out paint with a clean rag.

Summer

DAY 2:
PREPARING THE PALETTE
AND WORKING OUT THE
COMPOSITION

From now on I am preparing my own special mix of colors on my palette daily before I start work. This way I can dip my brush into a nice pile of paint, concentrating on the painting instead of having to stop and stir with almost every stroke.

The composition is a pyramid of figures against a background divided horizontally into bands of dark foliage, light sand, darker sand, and a very dark strip of recently moistened sand at the bottom.

In the day one stage when I had just filled in the background, the composition was sloppy and unformed. The pyramid of figures was feeble and too small, the central light strip of sand was far too wide, the bands at the bottom were undefined, and the top of the painting looked cramped.

After a day's work there is a firmer design to the painting. The central sand strip is reduced in depth, with a progression of darks below. The top of the painting is raised, and the figures are made warmer again; they now have more emphasis and bulk. The hat shown in the watercolor sketch (page 108) has been moved. It's an important element since it's the only form separate from the figures. It's now on the right side for better balance; also it looked rather silly having a woman's hat next to the man.

The warm colors needed are mixed daily: cadmium orange, cadmium green, and light ochre (left); cadmium scarlet and permanent yellow-green (center); and raw sienna and white (right).

The cool colors are also mixed every day: thalo green with cadmium orange (left) and ultramarine blue with alizarin crimson and cadmium green light (right).

Thalo green is mixed with burnt sienna and white.

A sand color and a foliage color are mixed: cadmium orange with permanent yellow-green and white (left) and cadmium orange with Indian yellow and permanent green light (right).

Cadmium red is mixed with burnt sienna and white.

A diagram of the composition divides the painting into horizontal bands.

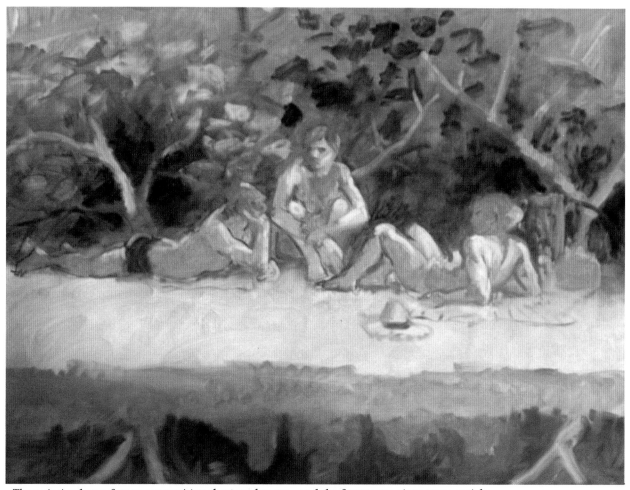

The painting has a firmer composition than on day one, and the figures are given more weight.

Summer

DAY 3:
BLOCKING IN COLOR

On the third day I go over the whole painting blocking in the figures in different colors as well as contrasting values of light and shadow. The man is now wearing a blue cap, and the right-hand girl has a pale turquoise towel around her head. The stripes of the towel have been added to establish the flatness of the beach.

At the same time, I'm painting the background, so that the painting proceeds as a unit. Some of the yellow ochre of the figures is introduced into the background; I add more varieties of green and more structure to the bushes.

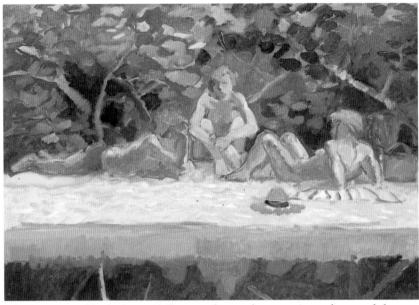

The figures are blocked in in different colors and contrasting values, and the background is roughly painted at the same time. The man wears a blue cap and the girl on the right a turquoise towel. The striped towel on the sand makes it look flat.

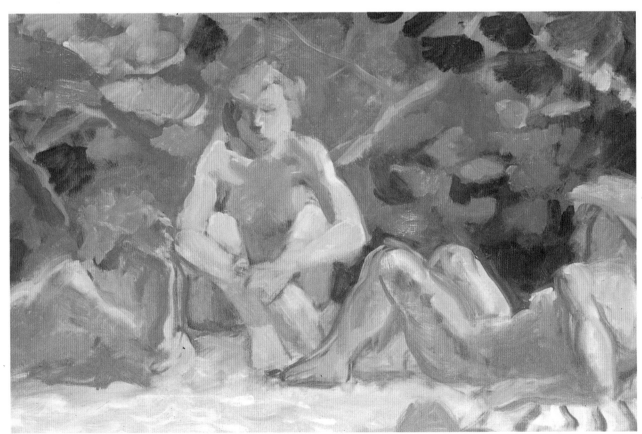

Yellow ochre from the figures is added to the background, and the foliage is more fully developed.

DAY 7:
MAKING A MAJOR CHANGE

On the seventh day I decide that the length of the man's legs and torso make an endless wedge shape that extends the painting too much to the left. So I make a major change—why not have a girl instead? I therefore reduce the width of shoulders and the length of the torso and the legs and make the forms rounder and fuller. The hat now migrates quite logically to her side.

The center figure has tied a dark bandeau around her head, which helps unify the face and head as a simple egg-shaped unit. The background is developing a design, with dark forms against a dull gold on the right and light leaves and branches against a purple-green on the left.

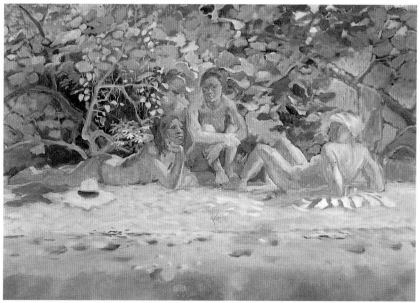

The proportions of the man's body have been reduced to those of a girl and the forms have been rounded.

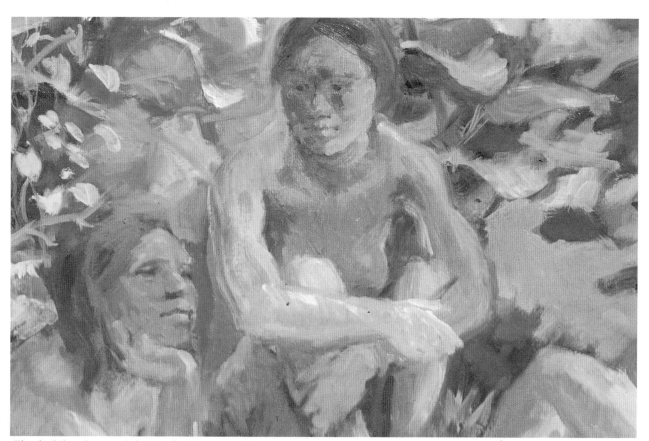

The dark band around the head of the central figure helps unify the face and head.

Summer

I have now worked out a color scale for the flesh colors of my figures. I want the colors to have strong contrasts of light and dark but at the same time to be rich in color and glowing with reflected light. For my basic dark I use yellow ochre, sometimes mixed with cadmium orange to darken it, sometimes with cadmium yellow to lighten it. For my very strongest dark I add burnt carmine with the yellow ochre and a little white.

For my lights reflected from the sand and flesh I use cadmium green light and white, and for my cool direct light I use emerald green and white. For my brightest direct light, I make a very pale pink of burnt carmine and white.

These are not naturalistic colors, but in relation to the overall painting, they give, I think, an impression of warm, sunlit bodies. I've done a diagrammatic version of the different color areas of the center figure to clarify this scale.

The basic flesh color is yellow ochre (left) mixed with cadmium orange to darken it (center) or cadmium yellow deep to lighten it (right).

The darkest flesh color is yellow ochre with burnt carmine red and a little white.

A mixture of cadmium green light and white gives the effect of reflected light on the flesh.

The cool direct light on flesh is a mixture of emerald green and white.

The brightest direct light on flesh is very pale pink made of burnt carmine and white.

This schematic treatment of the central girl shows the color scale developed for the figures.

DAY 14:
ADJUSTING VALUES
AND OVERALL SIZE

By the fourteenth day the girl on the left is wearing a white hat. This light patch makes a point of emphasis halfway up the triangle of figures, the brim continuing the curve of the back, thus defining a path for the eye to follow. The center girl's headband has changed to white.

The values of the sand have been clarified, the white part (a mixture of pale pink and yellow) made lighter and the damp sand progressively darker. I found the emphatic reflections on the wet sand disturbing, so I substituted more generalized lighter and darker areas within the continuous dark value.

The top of the painting has risen again, and the left side has contracted with the reduction of the length of the figure. The overall size is now 44 by 54 inches, a big change from 50 to 72 inches, but I needed that space at the start to allow the painting to move and grow.

DAY 18:
REFINING THE FOLIAGE

Everything is being worked on everywhere. The foliage has demanded daily sketching sessions—in the evening when there's no one on the beach, since I'm self-conscious about working in public. Every morning when I go for my first swim at seven, I collect a branch or two as models. I want a sense of depth and organic growth in the sea grape's trunk and branches, not just a flat-patterned mass behind the figures. I use my tape to show direction for the foliage.

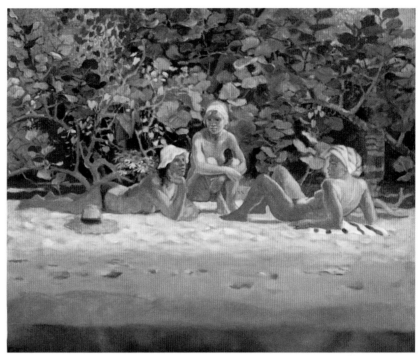

The light and dark values of the sand have been made more distinct. The reflections on the wet sand were too strong, so the lighter and darker areas were made less specific. I also added to and refined the foliage.

I used a strip of tape to show the intended angle of a sea grape plant.

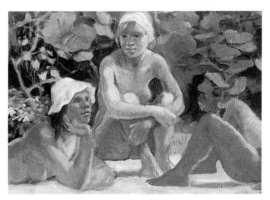

Here, the sea grape appears, painted in at the angle indicated by my tape.

Summary

DAY 22:
REFINING THE FIGURES

By the twenty-second day the figures have been further refined. This is not a finished state but is, rather, an effort to find the fullest and most satisfactory form within each pose.

The left-side figure has been completely repainted, the head lowered about an inch, and the torso and legs shortened again. I thought she still looked too masculine, and when I lightly drew the neck through the supporting hand, I found a very bad connection with torso. So I repainted her. This problem of faulty connections often arises when a form is interrupted and then continues later. I nearly always have to draw through the intervening object to make the two parts of the body connect properly.

DAY 29:
MAKING LAST-MINUTE CHANGES

By the twenty-ninth day all the figures have been repainted again. I've refined the hands and given the white-hatted girl a completely new face. I thought she still retained too many masculine characteristics from her previous incarnation. I've also reduced her proportions again. The central figure now has a green headband to avoid having three obvious white

objects on the girl's heads. The towel on the left is a dull red with a blue stripe at the base. I tried a brighter red, but it shot out of the painting and destroyed the triangle of figures. Many small motifs have been added to the foliage to give a greater variety of forms within the mass.

Is *Summer* finished? Probably not, but I want to stop since I have an urgent idea for another painting. I notice that I don't want to make any major changes in case they involve me in a lot of new work, so that's the time to put the canvas aside. I'll look at it with a fresh eye in a month or so.

POSTSCRIPT

One month later I've just had a new look at *Summer*, and heavens! I don't like that right-side, turquoise-toweled girl's torso and legs at all. The torso looks too long and the legs too puny. That must all be repainted, regardless of the repercussions. Now the impetus is there. I *want* to make the changes and no longer feel cautious about messing things up. So to work . . .

Two months later and I tackled *Summer* again. You can see this further stage on pages 94–95 at the beginning of this section. I've repainted the legs three times which has caused the torso to shorten. I've also done some more work on the foliage.

At this point the forms and relationships are well established. Summer does not seem to require any more changes for the time being.

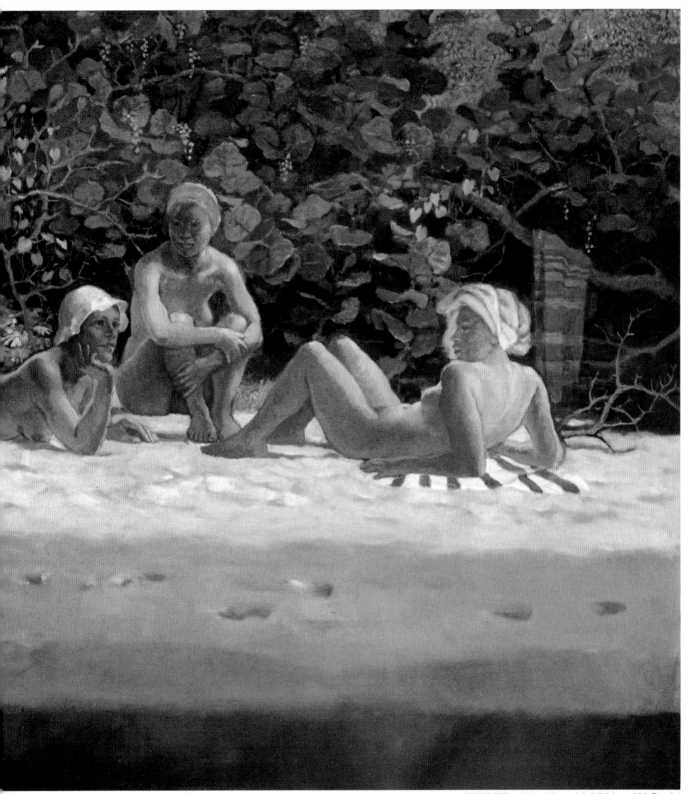

SUMMER, 1987, 54" × 44" (137.1 × 111.7 cm).

NIGHT, 1981, 52″ × 47″ (132 × 119.3 cm).

PAINTING POSSIBILITIES: PROBLEMS AND SOLUTIONS

This book is intended to liberate your own imagination by practical means; it is not meant to persuade you to paint in a certain way. Whatever technique you employ, you can use these keys I offer to unlock your own personal vision. So let us find these keys by looking at some of my completed paintings.

I have chosen as wide a range of painting subjects as I could find to show you just how varied figurative painting can be. The possibilities are virtually endless. In addition, I had something to say about the subject of each work, so that each became a challenge requiring a different answer. By identifying the problems, I found I was halfway to a solution. Some of these solutions may help you out of difficulties, too. I hope they will stimulate you to make discoveries of your own.

THE MULTIVIEW PORTRAIT

GEOFFREY, a multiple portrait of my husband, was conceived as a pattern as well as a portrait. If you hold the painting upside down, you can see the pattern more clearly.

In squares 4 and 7 the profiles face opposite ways but are linked in an arabesque curve from chin (4) to forehead (7). The dark background of square 6 continues as the shadowed side of square 9. Square 3 twists the curve back the other way with the face turned to the right to balance square 1. The diagonal profile in square 2 is to avoid the monotony of twisting vertical columns. The colors are nonnaturalistic except in square 5, the focal center.

The pattern of Geoffrey *is clearer if the diagram is turned upside down.*

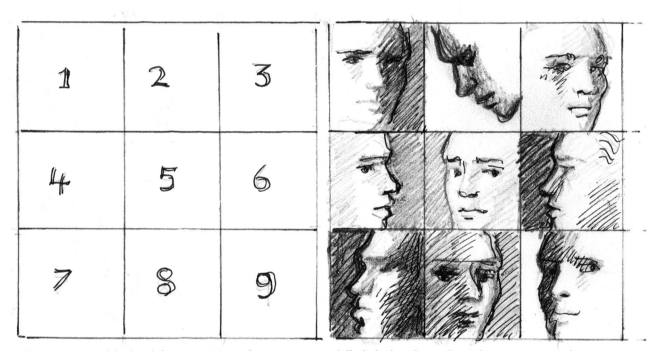

The contours and darks of the portrait in each square are carefully linked to those of an adjacent square to form patterns over the whole painting.

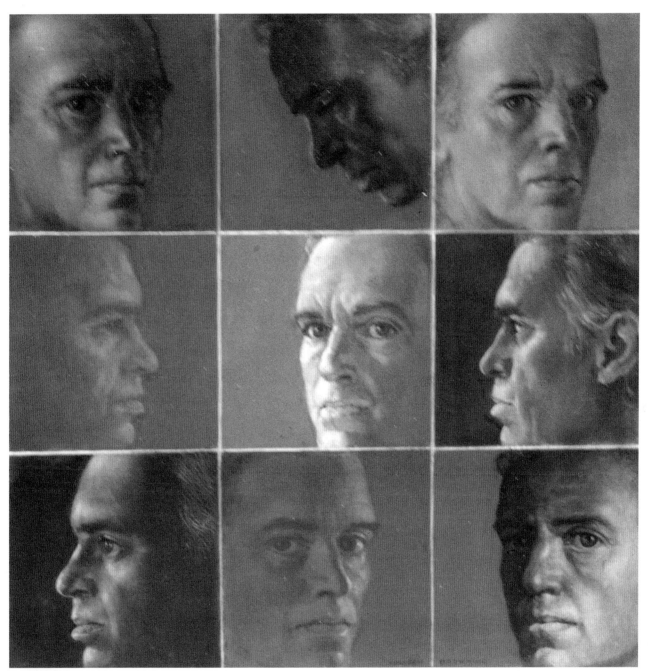

GEOFFREY, 1975, 20½" × 20½" (52.7 × 52.7 cm).

URBAN PATTERNS

CHEVRON is a work I owe to my fascination with the graffiti-painted subway cars of New York City. Their elaborately scrawled exteriors provide an abstract pattern through which real people can be seen framed in doors and windows. And there is the nice painterly paradox that in translating these abstractions, drips and all, I am being a superrealist.

I obtained a NYC Transit Authority pass to take photographs in the subway, much to the consternation of various suspicious characters who tugged their jackets up over their faces. A whole series of paintings sprang from this juxtaposition of the real and the abstract. *Chevron*, an apparently simple painting, was arrived at after I did pages of thumbnail

sketches, of which only a few are shown here.

As I experimented, I found that a vertical canvas did not work, two circles were unnecessary, and the flabby chevron should be more arrowlike. The design seemed cramped on a square canvas. Dark forms on a light ground looked a bit meager. The horizontal canvas worked better with the design. The

a

b

c

d

e

These thumbnail sketches for Chevron *are experiments with formats and the juxtaposition of abstract elements. A vertical canvas does not suit the composition, only one circle is needed, and the arrow is too weak (a). A square canvas cramps the design (b). The dark forms look too thin on a white ground (c). A horizontal canvas suits the composition better, and moving the circle inside the chevron seems to help (d). In this version the hues and values are too confused (e). Placing a dark circle on a light ground and a light chevron on a dark ground of its own shape seems an improvement (f). In the final sketch the whole ground is dark with a light circle and chevron and a black stripe in the chevron (g).*

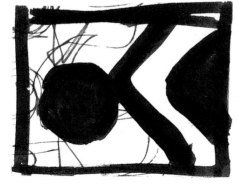

f

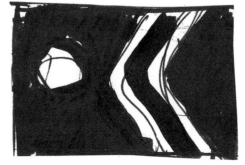

g

circle inside the chevron might be a solution. The colors and values were so confused that you couldn't see the design, just a mess. A dark circle on a light ground and light chevron on a dark ground was a possible variation. I finally decided on a light circle and a light chevron on a dark ground and eliminated the dark stripe in the chevron for simplicity. In the completed painting I depicted realistic heads inside the circle of the subway window and emphasized the abstract chevron and an arrow slanting in the opposite direction with color.

I wanted the most effective and dramatic relationship between the two bold, simple shapes of the circle and the realistic faces within the circle. The faces are blue, from the spray paint on the window glass, which ties them into the design and removes them somewhat from naturalism.

The two evenly placed faces serve an important compositional purpose. For example, four eyes in a line and two noses make a series of horizontals split by a vertical triangle at the bottom where the jaws divide.

CHEVRON, 1978, 23" × 17' (58.4 × 43.1 cm).

Urban Patterns

OK ME WE TEAM CAR divides horizontally into a top third filled with passengers and a bottom two thirds occupied by the side of a subway car covered with menacing graffiti that perhaps look as if they were trying to devour those inside.

The original layout was a very formal composition with the three even divisions made by the windows at the top. But it looked monotonous however much I changed colors and values around. Finally I discovered the solution: the horizontal was *too* even—it needed to be broken into two levels. So I raised the center window, preserving my formal structure but adding an irregularity for interest. Do you notice the difference?

The original composition was dull because it was evenly divided into three horizontal bands.

The composition is solved by raising the center window to provide an element of irregularity.

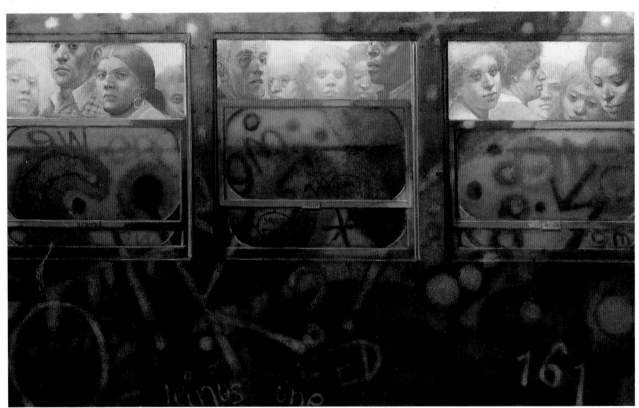

THE OK ME WE TEAM CAR, 1976, 50″ × 30″ (127 × 76.2 cm).

WOW CAR is a complicated painting in which patterns and subpatterns are superimposed on one another but without any depth. Everything remains on the picture plane, a mural of a subway car. You don't go through the plane even in the windows.

It is difficult to introduce words into a painting. Unless the shape of the letters is repeated in the composition, the word can remain completely unassimilated into the design. In the word wow here, the W and the two exclamation points are aligned with the green outline of the blue motifs, while the O is, of course, the ubiquitous circle seen also in the four windows. Because "Terry," "H13," and the dollar sign are names or symbols, they don't carry such a communicative statement as a more general word would; therefore, they can be used as decorative accents without drawing too much attention to themselves.

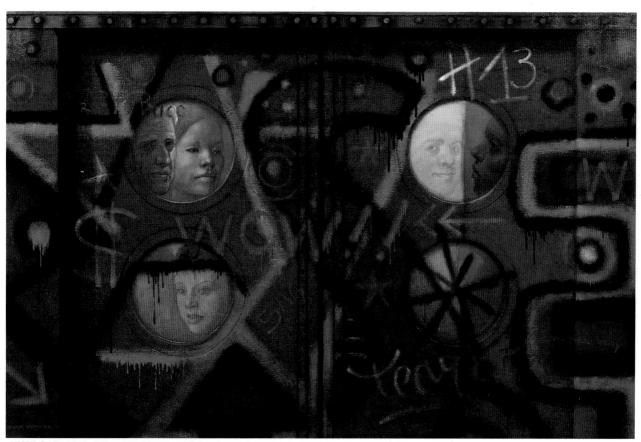

WOW CAR, 1978, 54" × 36" (137.1 × 99.4 cm).

EXOTIC PLACES

THE GHOST WOMEN OF ESSAOURIA was inspired by a Moroccan seaport on the Atlantic. Essaouria is still medieval in spite of anachronistic modern facilities such as telephones and electricity. Its narrow streets are lined with whitewashed walls, and all doors, window ledges, and shutters are blue, with an occasional yellow trim. The women are shrouded in white, with only their eyes showing over the nose veil and the tip of a high-heeled shoe peeking from below the long draped skirt. In *The Ghost Women of Essaouria* I particularly wanted to avoid the picturesque, come-to-Morocco kind of painting, while at the same time I wanted to emphasize the contrast between ancient and modern and the almost surrealist effect of the ghostly women.

In this picture, understanding drapery—and enjoying painting it—is of paramount importance, as there is no distinct figure, only folds over a moving form.

This picture changed its overall dimensions many times. More and more elements were eliminated, including any definition of the ends of the building, in order to avoid the "scenic" look yet preserve the medieval atmosphere. If you look at the painting upside down, you can see that a strong design underlies it. The windows and doors form stable elements. They are fairly evenly placed apart but are irregular in height and color, and they are set around the main vertical, two thirds of the way across the width of the painting.

This emphasis on a two-thirds/ one-third division creeps into one's work unconsciously. This proportion is often called the golden section; points of interest seem to fall naturally within its range.

As I said earlier, I am terribly self-conscious about sketching in public; I can't think about what I'm doing if I become a public entertainment. But one is relatively anonymous behind a camera, which I find invaluable for taking notes. The camera gives me quick, accurate information that I can use, if necessary, at a later date. So when something tells me that a painting may be hiding in a scene I see before me (a scene that won't always be available), I take a large number of photographs—general views, particular doors, windows, cracks, everything. Then later, in my studio, I lay them all out, re-live the scene, examine them with a magnifying glass for details, and so gradually come to know what I am trying to say in the painting and how to paint it. For this purpose, a poor photograph is sometimes better to work from than a well-composed one, since you're not tempted to reproduce the whole photograph.

The structural design element, achieved by placement of doors and windows of different sizes around a dominant vertical, becomes evident by looking at the painting upside down.

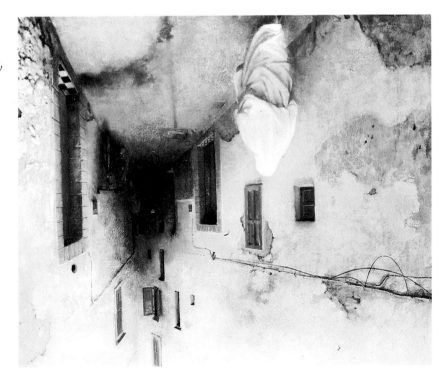

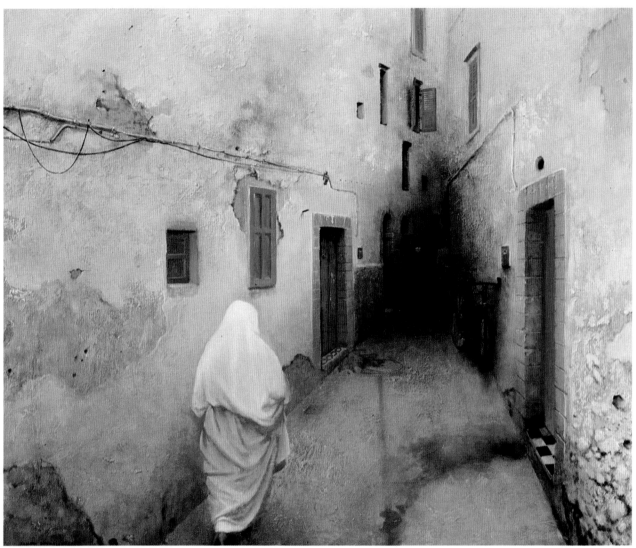

THE GHOST WOMEN OF ESSAOURIA, 1983, 48″ × 40″ (121.9 × 101.6 cm).

MYSTIC VISIONS

THE LETTER is one of a series of paintings on clairvoyants, in which I wanted to suggest that their role was part of the ancient classical tradition of sibyls and oracles. So for this picture, I used deliberately stylized backgrounds, making notes from the Roman fresco fragments in the Metropolitan Museum of Art in New York.

What I want to point out in this painting, however, is a large error, an example of getting tied up in a detail that you don't want to alter so that you end up making an even bigger error. I had painted the clairvoyant's left arm and hand holding up a locket to an intermediate stage, and then I had trouble with the hand. When I finally solved the hand—it is an important element because it links the two figures and is in the center of the painting—I started to have even more trouble with the arm. The hand and shoulder didn't connect properly through the arm. So I did a lot more work on the arm, but I didn't want too much to touch the hand, which I was pleased with and had spent much time on.

When the painting was finished, I took a couple of photographs, because a change of scale can show up surprising errors; and there was mine! The arm was too long from shoulder to elbow. If I hadn't been so adamant about not altering the hand, I could have started afresh, working from shoulder to elbow to hand instead of trying to connect two separated points.

It bothers me dreadfully to look at it. I haven't yet got up the enthusiasm to repaint the arm and hand (and perhaps the figure and perhaps the face, since one alteration generally leads to others) because I've been so involved with new painting projects.

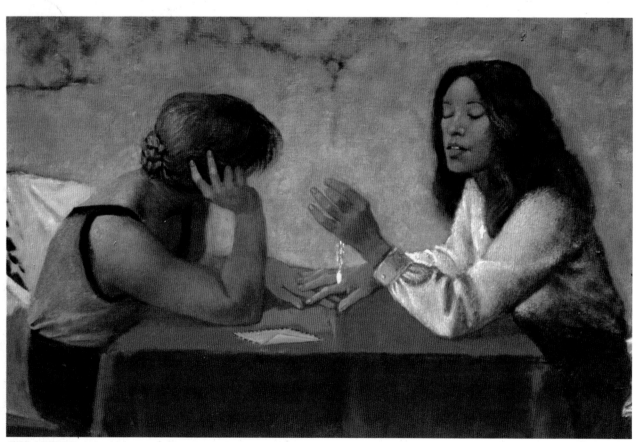

THE LETTER, 1985, 38½" × 26" (96.5 × 66 cm).

PSYCHIC FAIR is again a composition of a triangle formed by the two leaning figures. It is almost centered on the canvas but is intersected by the horizontal shape of the covered table.

This painting changed shape daily as it expanded or contracted. I must have used up a roll of tape calculating how much space was needed in relation to the figures. If I cut off both sides of the painting, don't you think the composition looks cramped, the figures lumped together?

I was going to end the painting just below the girls' knee, but then, peeling off more tape, I liked the extra amount of dark base, so I turned it into another table spread with a line of tarot cards. Their central position and their verticality, like three blunt fingers, lead the eye up to the two central figures.

Since I wanted a mixture of realism and stylization, I painted the background thickly with ochres and yellows and then incised it, allowing some of the original red ground to show through, in order to give the effect of the cracking gold backgrounds in fifteenth-century religious paintings. The clairvoyant herself is in clerical black with white cuffs instead of a collar. The cigarette smoke perhaps suggests incense.

In both *The Letter* and *Psychic Fair* the clairvoyant is using psychometry, a method of divination about a third person that employs an object belonging to that person. She is going into a trance while holding her client's hand.

In Psychic Fair *the two figures of the clairvoyant and the client leaning toward each other form a triangle.*

The figures look crowded in a contracted version of the painting.

PSYCHIC FAIR, 1983, 46" × 28" (116.8 × 71.1 cm).

In an expanded version of Psychic Fair, *three tarot cards on a table, added in the foreground, focus attention on the figures.*

Mystic Visions

CONSULTATION is based on the asymmetrical triangle formed by the two figures. The curve of the back of the client leads to the sharp diagonal formed by the clairvoyant's right arm. The apex of the triangle is her head; the other side of the triangle slopes abruptly down her left arm.

To stabilize the painting, I developed the tabletop and the right arm of the client, which practically forms half a rectangle, and made emphatic right-angled creases in the tablecloth. The cup and saucer act like a full stop at the bottom of the painting. I added two unobtrusive horizontal and vertical cracks in the background for both visual and symbolic purposes; they not only suggest the antiquity of the wise-woman tradition but also the breaking of the boundaries that separate normal experience from the extraordinary. I softened the creases and the cracks in the finished painting.

A note about using oneself as a model might be useful here. That's my back in the painting. Painting myself has nothing to do with vanity and everything to do with convenience. The artist is available all the time—without salary.

Painting oneself is another reason why mirrors are so essential. I have a swinging standing mirror on a wheeled base, which I can move around easily. I have also a good-size hand mirror and another large mirror fixed to the wall of my studio behind me. That mirror is also useful because I can turn and see my painting at a distance and in reverse.

For the back view here, I put the painting in front of me and the standing mirror behind me, and I looked at the reflection of my back in the hand mirror held in front of me. I could then compare the reflection of the real back with the painted image before me.

You can only remember so much in one long look. So you have to adjust in little bits at a time, returning to the mirror image again and again. You may get a crick in your neck, but it works.

Don't forget that in a mirror you are seeing in reverse. Your right hand becomes your left hand in the reflection. Although I'm right-handed myself, my left hand is far more flexible, having been used as a model for the right hand for years and years.

A triangle is emphasized by the black line running along the client's back to the top of the clairvoyant's head and down her left arm.

Here the black outline is removed, and variations in its thrust are provided by stressing the edge of the table on the left and the napkin, which acts like an arrow.

The client's bent right arm and the right-angled creases in the tablecloth stabilize the painting. The cup and saucer keep the eye from sliding out the bottom.

CONSULTATION, 1985, 33" × 29" (83.8 × 73.6 cm).

In the painting the right angles in the wall cracks and the creases of the tablecloth have been softened, and a yellow patch and the client's pale orange blouse have been added for color.

Mystic Visions

THE ADEPT is based on a diagonal linking a series of horizontals. The painting caused me a lot of problems, however, because of the model's blonde hair. I was not painting a portrait per se but evoking a person with long blonde hair who was almost too classically beautiful to be able to paint easily.

I make diagrams before and during a painting because color sketches usually don't work out when enlarged and have to be changed. But I did the color sketch shown here after the painting was completed in order to show you some of the difficulties and how I tried to solve them. Here is a list of some of the many things wrong with the sketch.

1. The table is too bright, too important, and there is too much of it.
2. There is no sense of perspective in the table—the vertical edge is wrong.
3. The background is too dark, which, combined with the dark skirt and white blouse, makes the painting too contrasty.
4. The cards on the table are in a muddle; they have no design.

Here is a list of what I did to rectify these compositional failures.

1. I painted the table a medium gold-brown, very close in value to the background. This pushed the table back and made it less obtrusive.

The composition of The Adept *is a diagonal, formed by the figure, connecting the several horizontals of the sofa, table, sofa back, and band above the figure's head.*

A color sketch of The Adept *reveals such faults as a too prominent table in an awkward perspective, too dark a background, and lack of design in the arrangement of the cards.*

2. I reduced the picture in height, bringing the horizontal band nearer to the head so that the main design elements are more closely linked.
3. I also reduced the picture on the left side, which made the table smaller, and added patterns to the cards.
4. I subdued the contrasts in the values and gave all the colors a family relationship, except for the blue of the belt and the design on the cushion. I liked them for "seasoning."
5. I used the bright yellow cushion as a frame for the figure. The two black borders of the cushion serve as sentinels on either side.
6. By changing the angle of the edge of the table and the cards, I suggested a somewhat more natural perspective.
7. I liked the idea of astrological symbols in the background but felt the eye was distracted by them on the band at the top, so I subdued the band, lightened the background, and put them in faintly in a different color. I think that gives a nice, unobtrusively patterned interest to the largest plain area in the painting.
8. I added my cat to keep the top of the sofa from running off the right side of the canvas.

Glazed variations of *The Adept* appear on page 50.

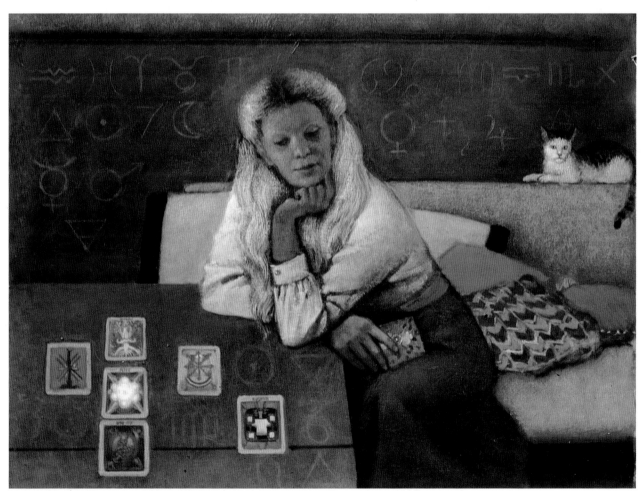

THE ADEPT, 1984, 27" × 34" (68.5 × 86.3 cm).

In the final version, the composition is firmly integrated by linking the rectangles of table and sofa and by eliminating the contrasts of table and background.

TROPICAL IMAGES

METAMORPHOSIS is one of a series of complex paintings I did in my studio in Grenada, using plants that I had grown as models. The theme was the transformation of woman into garden or the unity of all fertile, flourishing things in the sun. To express unity and universality, I purposely avoided a focal point in this painting. The surface is a dense, all-over pattern, and the woman also is broken up into spots of light and dark so that she becomes an almost invisible extension of the luxuriant growth around her. To strengthen the sense of unity, I used totally unnaturalistic colors, even making her face green. In the context of the other greens, however, it doesn't look so surprising. The mass of complicated shapes is a carefully worked out design so that (I hope) the eye is not fatigued and can wander around the painted garden at ease.

Linking elements of the composition are four white objects and a patch of white frills.

The flower shooting out of the hand repeats the shape of the hand.

The pattern of light and shade on the leaves of the chenille plant is repeated on the woman's arm and dress.

A vertical running from the chenille plant to the lily leaves to the philo-dendron helps hold the painting together.

Two patches of little yellow flowers form a contrast with the larger shapes.

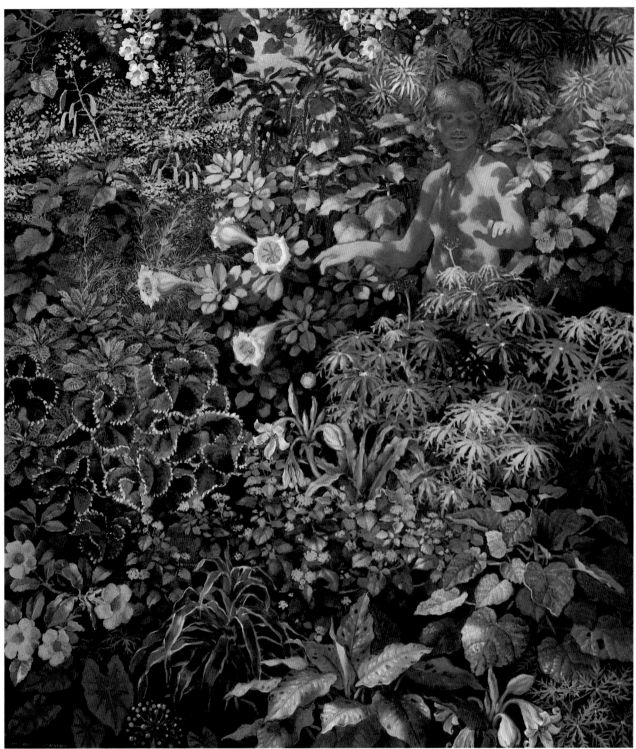

METAMORPHOSIS, 1981, 52″ × 59″ (132 × 149.8 cm).

Tropical Images

DANAË I, unlike *Metamorphosis*, has a focus, a present-day Danaë. You probably know the Greek myth of the Princess Danaë, who was imprisoned in a tower by her father; there she was visited by the god Zeus, as a shower of fertilizing gold, who fathered her son, Perseus. It was seeing the scattered spots of sunlight coming through the brim of a straw hat onto my face, as I passed my studio windows one day, that sent me off on a series of Danaë paintings—a continuation of the *Metamorphosis* theme of the fertilizing effect of the sun on living organisms.

As in *Metamorphosis*, I painted the figure in nonnaturalistic colors in order to relate her to the purples and mauves of the flowers that percolate through the painting. The tiny spots of sunlight on her face and shoulder repeat the yellow flowers below her waist and the intricate leaves on the right side of the painting above her head. The large mauve lilies on the upper left are so visually demanding that they prevent the figure from being too isolated. Their value and color are repeated as accents twice at the bottom of the canvas.

In this detail of Danaë I *the spots of sunlight on the figure are visually linked to the small yellow flowers near her waist and the leaves above her head.*

The pale mauve lilies in the upper left and the small accents of the same value and color at the bottom help link the figure with the foliage.

A curving line, passing from the dark red bush on the left down to the blue and crimson leaves toward the bottom and up to the dark leaves on the right, frames the figure.

A sort of undulating loop runs from the left side of the canvas in the dark red bush behind the yellow croton, down through blue and crimson leaves, and up to some darkish leaves on the right side. This loop provides a frame for the figure. It's not obvious, but I think it gives a sense of stability.

To gauge the effect of a color or value in an area of a painting *without putting on any paint*, I've found that an excellent trick is to use colored tapes of various widths. I put such bits of tape on the canvas and stand well away from it to see if they make a path for the eye. I check from as far distance, by looking in the mirror, and by turning the painting upside down. If the effect is unsatisfactory, I try another color. In this way I can test different colors without messing up the paint.

You always have three advisers at hand to help—distance, a mirror, and an upside down painting. The suggestions of all three are good. For some years now I've had a fourth adviser—my colored tape.

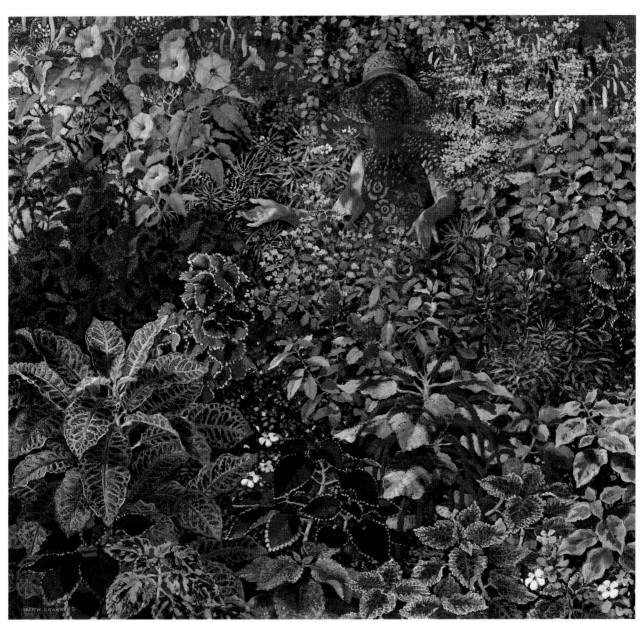

DANAË 1, 1980, 52″ × 48″ (132 × 121.9 cm).

Tropical Images

DANAË II is similar in feeling to Danaë I, but the forms of its leaves and flowers are larger here in relation to the canvas size—which is large, and the figure is now a pivotal element, since it is the only blue in the painting.

Bright cadmium scarlet (almost my favorite color) is a continuing link throughout, acting both as background at the top of the painting and as foreground in the leaves and flowers at the middle and bottom. The face, as in *Danaë I*, is in nonnaturalistic colors. Where normally there would be shadows or shadows with reflected lights in them, I have used very light values of violet and turquoise to connect the figure with the exotic growth.

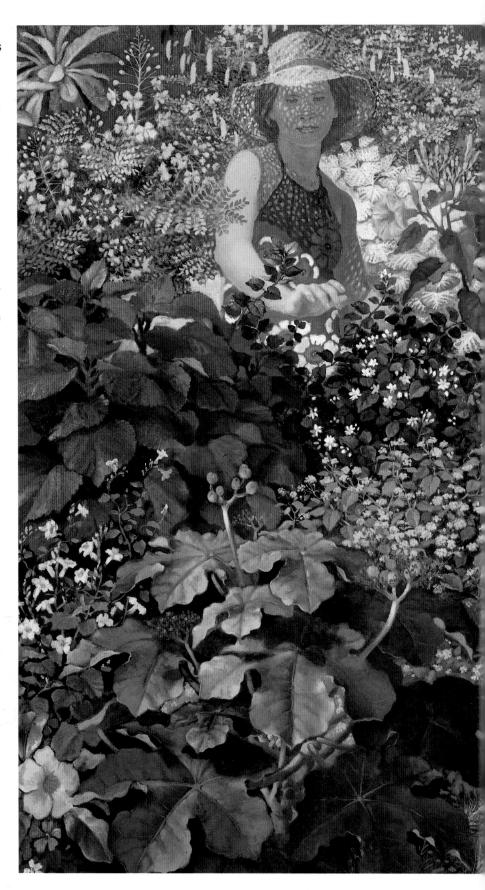

DANAË II, 1984, 39" × 59" (99 × 149.8 cm).

SEASIDE SCENES

FOUR was the first of a beach series, and it caused me a lot of trouble. The compositional entwining of the figures and their beach towels, on which the stripes formed important directional signals, was not too difficult, but relating the figures to that large area of sand kept me in frustrated irritation for months.

My subjects reflect what I have seen and been moved by. A powerful image can spark a whole series of paintings. Therefore, living as I do in the Caribbean, overlooking a perfect beach, it was inevitable that beach paintings would appear in my work.

At the beginning of a series, I often find the first one very difficult, because I'm not sure exactly what the visual problems are, how to solve them, and what I want to communicate. But after I have done several paintings on the same theme, when I understand the problems and have defined my position, they become easy, too easy, and the solutions become facile. A mannerism or style takes the place of emotion and invention, and then the series is finished.

I tried every color combination for the flesh, towels, and sand. For a while it was a black sand beach.

Finally, in a rage I started whiting out the whole painting with a big heap of titanium white, starting at the right side. But suddenly the combination of white on one side and the dark remaining from the previous black coat on the other side started to make visual sense. If you cover over the bottom left of the painting with your hand, you can see how spotty the group looks on an undifferentiated background. I mentioned earlier that rage can be creative, as it makes one bold in taking chances. It was certainly so in this painting.

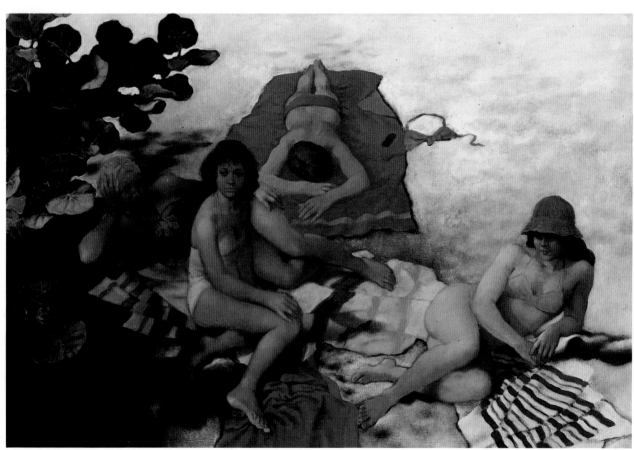

FOUR, 1983, 59" × 39" (149.8 × 99 cm).

PICNIC was my next beach painting. You can see that I've broken up the sandy expanse in the background with horizontal blue shadows to give a sense of depth. I also love the opportunities for color that bathing suits provide while still preserving the contours of the body. The central woman drying herself with a towel is another example of using drapery as a creative element in a composition. I kept the drawing I made of the model posing for me.

For compositions of semi-nude figures, such as this one, I use models. I plan and start painting without them, since I'm not yet sure what positions I want. Then when everything is tentatively organized (since of course there will be changes), I hire my models. It is also easier for them to arrange themselves into the positions I want if they see the painting.

I do many sketches—on tinted paper with white and dark pencils to establish the modeling of forms to be translated into light and dark paint. Each sketch has a slight variation in the pose, giving me a range of possibilities to use when the model is no longer there. In all the beach paintings I drew the models in New York and painted them in Grenada from my sketches.

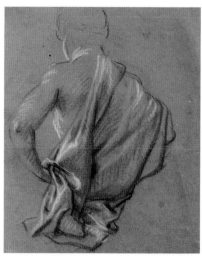

The pencil sketch of a woman drying herself became the central figure in Picnic.

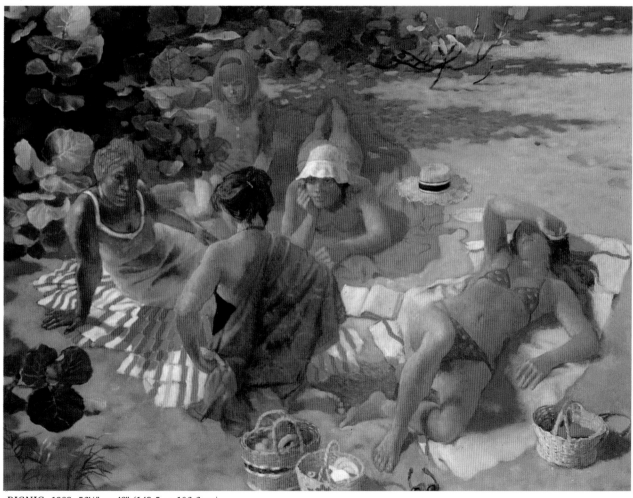

PICNIC, 1982, 56½" × 42" (143.5 × 106.6 cm).

INDEX

Back, drawing in profile, 28
Background
 establishing figures in, 110, 142
 reversing, 88
Brushes, 44–45, 78, 93, 110

Chiaroscuro, 52
Clothing. *See* Costume
Color
 basics of, 77
 blocking in, 97, 114
 changing, 89
 developing, 116
 diagnosing problems with, 58,
 134–35, 142
 mediators, 58, 60
 refining, 98
 testing, 139
 and value, 52, 54–57, 65
 variations, 61–65, 136, 138, 140
Composition
 adjusting, 99, 100, 131
 basics of, 66–67, 76
 creating mood through, 70–71
 creating movement through, 68–69
 organizing, 101, 143
 symbols as elements of, 72–73, 135
 triangular, 131, 132
 working out, 112, 124, 126, 134–35
Contrast, 52, 56, 57, 65, 67, 102, 135.
 See also Value
Costume, 32–35, 103
Crosshatching, 24–25

Diagonals, 68–69, 101, 103
Distance, conveying, 102
Drapery, 35, 143. *See also* Costume;
 Folds, depicting
Drawing
 faces, 14–25
 figures, 26–29
 position for, 12–13
 preliminary, 109
 on tinted paper, 36–41, 109, 143

Errors
 correcting, 84, 134–35
 in faces, 21, 22, 25
 in figures, 26, 28, 130

Eyes
 painting, 84
 placement of, 16–19, 21
 structure of, 20

Faces
 frontal view, 16–17
 modeling, 24–25
 painting, 78–80
 three-quarters view, 18, 21, 105
Feet, drawing, 30
Figures
 drawing, 26–29
 proportions of, 26–27
 refining, 105, 118
 relating to background, 110, 142
Flesh, painting, 78, 80, 83, 87, 116
Folds, depicting, 32–35, 103
Foliage, painting, 117, 136, 138

Glazing, 48–49, 50, 86, 90, 104
Grid, imaginary, 16–19

Hands, drawing, 31
Head
 and face, 16–25
 modeling, 24–25
 and neck, 14–15
 three-quarters view, 18, 21, 105
 tilted, 17, 105
Highlights, 38–39
Horizontals, 68, 70, 103, 124–25

Impasto, 51

Legs, drawing, 29
Light
 modeling with, 24–25, 52
 reflected, 38

Mediators, color, 58, 60
Medium, 45
Mirrors, usefulness of, 13, 132
Modeling
 fabric, 103
 form, 36, 83
 with light and shadow, 24–25
 with line, 24
Model, artist as, 132

Models, 12
Mood, creating, 54–57, 70–71, 86
Mouths, drawing, 23
Movement, creating, 68–69

Neutralizing paintings, 90–93
Noses, drawing, 22

Painting
 basics of, 48–51, 76–77
 changing, 86–93, 115, 118
 color in, 58–65
 creating, 78–85
 developing, 94–119
 materials, 44–47
 neutralizing, 90–93
 position for, 46–47
 supports, 46
 value in, 52–57
Paints, suggested, 44
Palette, 45, 112
Palette knife, 45, 51
Pattern, 99, 122, 124–25, 127, 136
Pencil, holding the, 12
Photo references, 96, 124, 128
Position
 for drawing, 12–13
 for painting, 46–47
Portraits, 122–23
Proportions
 of the face, 19
 of the figure, 26–27

Remodeling, 90–93

Scumbling, 48, 103
Shading, 24–25, 38
Size, adjusting overall, 117
Supports, painting, 46
Symbols, 72–73, 135

Tinted paper, 36–41, 109, 143
Tone. *See* Value

Value, 36–38, 52–57, 84, 86, 117
Verticals, 68, 70, 103, 124–25
Viewing your work, 13, 82, 84, 139
Volume, 53, 103. *See also* Modeling